California Tiki

California Tiki

A History of Polynesian Idols, Pineapple Cocktails and Coconut Palm Trees

JASON HENDERSON & ADAM FOSHKO

Foreword by Otto von Stroheim, Tiki Oasis

THE
History
PRESS

Published by The History Press
Charleston, SC
www.historypress.com

ISBN 9781540235305

Library of Congress Control Number: 2018936071

Notice: The information in this book is true and complete to the best of our knowledge. It is offered without guarantee on the part of the authors or The History Press. The authors and The History Press disclaim all liability in connection with the use of this book.

To Rebekka and Matt, my sister and brother, for sharing my love of the past.
—Jason

To my wife, Blinzia, for always being my inspiration and my paradise found.
—Adam

Contents

Foreword, by Otto von Stroheim 9
Preface 13
Acknowledgements 15
Introduction: Lighting the Volcano 17

1. Going Native, California Style 25
2. Tiki and *The Man in the Gray Flannel Suit* 32
3. Tiki Music: Martin Denny, Les Baxter and Exotica 40
4. Tiki Music: The Tiki of Surf 51
5. Tiki Film: Elvis Rules the South Pacific and
 Gidget Goes Everywhere 62
6. Tiki TV: The Intimacy of Escape 78
7. Tiki Down: Woodstock Kills the Mai Tai 87
8. Tiki Resurgence: The New World of Tiki
 (And What to Serve There) 93
9. Some Final Thoughts 113

Sources 115
Index 119
About the Authors 125

Foreword

Discovering California, the Cradle of Polynesian Pop

By Otto von Stroheim

I grew up in Southern California in the 1960s and '70s. I wasn't aware that the roadside playgrounds and the amusement parks next door to where I called home were a new and exciting experience unique to the state of California and formed a state of mind unique to Californians. As a kid I didn't realize that I was living in the golden age of pop culture.

In my childhood world, most houses had tropical landscaping. Almost every front yard had Bird of Paradise bushes, jumbo Elephant Ear plants and banana trees and so did all the restaurants, which were also Space Age–themed like Norm's and Ships. *The Jetsons* and *The Flintstones* were my favorite cartoons, and the world around me reflected their scenery—together! Googie coffee shops were created in California. The rest of the country had diners that were self-contained in small boxcars, but in California, our diners were like satellites or space ships expanding out into the sky with Las Vegas–style lights and signage. This is where I had breakfast with my grandma. I lived one block away from the Golden Arches when I was in kindergarten. If fast food wasn't born in California, it certainly grew up there: Southern California car culture gave rise to a nascent fast food scene that included Taco Bell, Del Taco, A&W Root Beer, Der Wienerschnitzel, Shakey's Pizza, Fosters Old Fashion Freeze and, of course, McDonald's.

When I was young, we didn't go out of the state on vacation much, but we often went to theme parks on the weekend. SoCal was a myriad of theme parks like KNOTT'S BERRY FARM offering a glimpse of the Wild West and the cowboys' Native American adversary; DISNEYLAND offered a smorgasbord

Otto von Stroheim, one of the founders of Tiki Oasis, 2017. *Jose Lepo.*

of Americana fantasies; and local amusement parks such as BUSCH GARDENS and PORTS O' CALL offered accessible escapism within minutes of my South Bay Torrance and later San Fernando Valley home. Other local theme parks that evoked other worlds and allowed for world travel without leaving your own neighborhood included JAPANESE VILLAGE & DEER PARK and PACIFIC OCEAN PARK in Santa Monica, which blended Exotica and Space Age Modernism with the beach and surf culture of Santa Monica.

As if Googie diners, fast food and amusement parks were not enough, California is home to the world's largest movie industry, Hollywood. From the 1920s to the 1970s, thousands of westerns were shot in the Simi Valley and San Fernando Valley hills, and *Batman* and *Rebel Without a Cause* and hundreds of other movies and TV shows were shot in the middle of LA at Griffith Park. It's no wonder that the fantasy islander-themed restaurant and nightclub genre of Tiki style would be born in Hollywood.

The three biggest players in Polynesian restaurants/Tiki bars all came out of California via Hollywood. In 1934, Don the Beachcomber established its fiefdom in Hollywood and then branched out to Chicago and Waikiki.

Eventually, Gantt/Beach's enterprise became a far-reaching corporation with over twenty restaurants and a commercial line of drink mixers. Trader Vic soon followed with a franchising deal with Hilton hotels that would put his restaurants around the world, including exotic locales like Amman, Jordan; Dubai, United Arab Emirates; and Mahe Island in the Indian Ocean's Seychelles. Of course, a line of Trader Vic's drink mixers, blended rum, cooking sauces and condiments followed. Then came actor Stephen Crane expanding his Luau from Beverly Hills to the Sheraton Hotels chain with an upscale concept called Kon Tiki Ports and ten Polynesian restaurants. Crane's Kon Tiki Ports was Chicago's largest restaurant in volume, grossing more than $2.3 million in 1966. (Oddly, that same year Crane felt "the Polynesian theme had reached a plateau.") Both Vic and Steve admitted that they learned the Tiki trade from Gantt/Beach, making Donn the creator of the Tiki bar and Hollywood the birthplace.

After the surge of tropical of the '30s and '40s came Hawaii statehood in 1959. In the 1960s, a new generation took the Tiki torch and ran with it into the surf. Surfers wore Tiki god necklaces, used Tiki statues as mascots to guard over their local surf spots and wore Hawaiian shirts in homage to the birthplace of surfing.

Pop culture and Hollywood are heavy influences that gave rise to Polynesian Pop, but another big factor is California's proximity to Polynesia. At the turn of the century, the only way to get to the ukulele-laden, hula girl–inhabited tropical island of Hawaii was by cruise ship. The Matson cruise lines based in San Francisco dominated South Seas travel for decades, carrying passengers to a variety of stops throughout the South Pacific. San Francisco Bay's Oakland port is one of the largest ports in the United States, and it's also the point on the mainland nearest to Hawaii. (Technically, the nearest point is 120 miles north of SF, but who's counting?) Matson lines also sailed out of the Port of Los Angeles. Los Angeles and the Port of Long Beach are usually ranked one and two as the largest ports in the United States, while Oakland was listed as the number two largest shipping port in the world in the late 1960s.

THE POLYNESIAN POP WAVE ROLLS ON

Los Angeles artist and Tiki enthusiast Jeffrey Vallance identified "The Four Generations of Polynesian Pop" as the original movement from the 1920s to

the 1960s; the second generation, of which Vallance was a prominent figure, took place in late 1970s to early '80s; the third generation (my generation) began in the mid-1990s; and the fourth wave came after the publishing of the books *Taboo: The Art of Tiki* (1999) and *The Book of Tiki* (2000) and my zine *Tiki News* (1995). I would also include the very first edition of *The Grog Log*, published in 1996 as a photocopied self-release by Beachbum Berry.

With these publications the scene is set. *The Book of Tiki* provided the history of the Polynesian Pop movement; *Taboo* revealed the artists of the second and third generation and established Tiki as an art movement; *Tiki News* zine provided social networking before the World Wide Web was established (we now have Tiki Central, Critiki and hundreds of websites dedicated to Tiki); and *The Grog Log* provided the knowledge of the Tiki drink, the tropical cocktail, the elusive elixir that was the ultimate allure for visitors to Polynesian restaurants.

As the fourth wave continues, the infrastructure is in place for sustained growth. Sven Kirsten has published *Tiki Pop* and other offerings that document every facet of Polynesian Pop. *Taboo* paved the way for more artists to get involved in the Tiki scene, resulting in group shows of Tiki art all over the world. I subsequently curated three large group shows and published catalogues to accompany them. *Tiki Art Now* volumes 1, 2 and 3 capture the Tiki art scene of the early 2000s. And now, the craft cocktail movement has embraced tropical drinks thanks to the undying efforts of Beachbum Berry.

The fourth wave of Polynesian Pop lovers never subsided. Rather than a Tiki revival, it appears that Polynesian Pop has continued and is here to stay. The lost years of Tiki style, the two decades of denial from the mid-1970s to the mid-1990s, will soon be seen as a lull in a long Polynesian Pop history.

—OTTO VON STROHEIM, TIKI OASIS

Preface

I came to Tiki late in life—in fact, I barely brushed against the culture throughout my career as a writer. I had other fixations: gothic horror and vintage paperbacks were my preferred escape, and I could talk about them at length with anybody that I could get to listen to me. But somehow the land of Exotica failed to capture my attention until by some accident I became obsessed with the world of beach movies. I was working on a book to follow up my Alex Van Helsing adventure series and wanted to create the story of a monster-hunting surfer girl. As I was doing the research, I became more and more enthralled with midcentury American culture. I followed the youth culture of the beach party movies back from American International and to the original beach movie Eden, the 1958 film *Gidget*. *Gidget*, with its other world just to the side of the one that boring parents of the 1950s inhabited, spoke to me very differently from what I'd expected or how I'd seen it described. And that was when I fell down the rabbit hole.

I only knew about Tiki culture from its edges, the occasional palm tree in a television show, this fascination with Polynesia after World War II that shaped American culture for about three decades after the war. I decided I wanted to know: where did this culture come from, and ultimately, where did it *go*? What I didn't realize was that the answers were surprising and often tragic—and that the culture lives yet.

In this book, Adam and I explore a cultural expression that we fell in love with from a historical perspective. It's a beginner's tour of Tiki Culture

that starts with the Pacific theater and moves to the end of the first Tiki movement, roughly around the Tiki of Woodstock. If you know nothing about Tiki, this book will give you an idea of where it came from and what it means. If you're part of the amazingly vibrant Tiki culture that has been booming for over twenty years now, I'm hoping that some of the explorations of the history will be new even if the facts themselves are familiar. Adam and I have met so many people who express themselves in the language of Tiki, and we're constantly learning from them. To all of them we extend our thanks and beg their indulgence wherever we get it wrong.

Thanks, and let's explore.

—Jason Henderson

Acknowledgements

Lots of people helped in putting this book together, but we'd especially like to thank Hasty Honarkar of the Royal Hawaiian for her gracious expertise about Tiki chic, Kort Pearson of the Laguna Riviera in Laguna Beach for his vision in keeping the Laguna Riviera a jewel of the West Coast, Otto von Stroheim for his ambassadorship to the work and world of Tiki, Julia Guzman for her photography, research and patience and Laurie Hall for her always clear-eyed wisdom. Whatever we get right is due to all of them, and whatever we got wrong is all on us.

We'd also like to thank the late great James A. Michener, who planted the seed of Bali Ha'i; Rogers and Hammerstein, who watered it; the servicemen and women whose sacrifices made it possible to thrive; and the awesome California and Pacific Tiki enthusiasts of today who keep the torches burning. To them we say thank you and Tiki Aloha!

Lighting the Volcano

By Adam Foshko

I t would be easy to start a book on California Tiki and its influences with an ancient tribal saying or the kind of wisdom that one might find on a cocktail napkin in a dimly lit Tiki bar in North Hollywood, El Segundo or San Diego. Those kinds of sayings are great and so are those kinds of bars and restaurants—not always exclusively for their lavish drinks and playful culinary contributions but for what they represent: an escape from the increasingly technological complexities of modern day living. The harder we work—and the less organic the world around us seems to be—the more the need to escape creeps into our bones until finally we break out, taking refuge in the belly of adventure, to enjoy the captivating world that the island life promises and then share that unique experience with others still mired in the mundane.

Like so many Americans, I read *Kon-Tiki*. And though I was just a kid and it was many years after it had originally been published in 1947, I had been caught up in the enormous groundswell of its rediscovery in the mid-seventies, as well as the documentary that was released way back in 1950. As I sat there, reading the book by the pool in our home in Encino, California, I was captivated by a life far away from the one I had in Southern California—far away from the responsibilities of school, homework, chores and other social obligations—and catapulted out beyond the horizon, over the crashing waves and onto the balsawood boat that Heyerdahl constructed for his journey. I had been transported—escaping to the sweet leisure of the sea and what must have been the equivalent of island life—to a time

Thor Heyerdahl captivated the world with *Kon-Tiki*, his account of his five-thousand-mile sea voyage from South America to the Tuamotu Islands in a hand-built raft. *Wikimedia.*

of great excitement, grand discovery and bold adventure. The adventure of a lifetime.

In 1947, Thor Heyerdahl's account of the journey was meant to demonstrate the possibility of the migration of ancient seagoing peoples of Polynesia. However, his description was so gripping and thrilling that it did more than contribute to the annals of ethnography or cultural anthropology, it was culturally *incendiary*—igniting the fires of an entire generation. And that's what was so interesting: it wasn't Heyerdahl's actual theories of oceanic Polynesian migration that captivated Americans, it was the artfulness of the tale he told—describing his three-month journey and

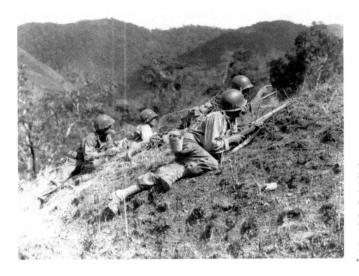

American forces at the Battle of Luzon, 1945, one of many battles of the Pacific war between the Allies and the Empire of Japan. *Wikimedia.*

subsequent landing on an island near Tahiti. It was his story that did it. And we were ready to hear it.

Up until this time, America was still recovering from World War II. And though the Allies succeeded in stopping both the Nazis under Hitler and Japan under Hirohito, they had seen a significant amount of hardship, enduring some of the most brutal conditions and fighting in the islands of the Pacific theater. However, many of the servicemen engaged in the fight against Japan had also been stationed in Bora Bora and Hawaii and sampled firsthand the Polynesian lifestyle and culture. This was particularly true for the navy. For many soldiers, especially those from middle America, this was their first exposure to a world so different from their own. Yet despite the region's differences to Kansas or Oklahoma or the Dakotas, it was incredibly inviting—the calm of the waters, the ease of the lifestyle, the allure of the women. As brutal as the fighting had been, this comingling of these two cultures somehow had made the intense fighting, the horrors of war and the rigors of duty more tolerable. More than that, though, the culture became a touchstone for many of them—something that they all shared, something they would want to take with them. They had all been part of a great adventure, an experience that changed them, possibly the greatest of their lives. At least that's the way James A. Michener put it when he wrote *Tales of the South Pacific* in 1947: "I didn't care what the guys said now, but in a few years they were going to look back and realize that this was the greatest adventure of their lives."

Michener's Pulitzer Prize–winning novel—a collection of nineteen episodes that depicted the human side of World War II—drew heavily from his time in the navy and stationing on Espiritu Santo Island in the New Hebrides. But unlike other wartime reads, Michener's book painted an incredibly vivid picture that—very much like Heyerdahl's story—superseded the reality or even the memory of things, places and events and immortalized them in a tableau of artfully crafted fiction. The result was something greater than itself, something that concentrated and magnified the experiences of the people who went to war—and the Polynesian influences they encountered—and made them readily available to be experienced over and over. Again, it was the story.

In addition to this, Michener also went a step further, introducing the island (and the idea) of Bali Ha'i: a distant, tranquil place of happiness that could be seen on the horizon but never visited—a close but unattainable vision of paradise. Bali Ha'i wasn't only central to his book; speaking directly to the many sailors who had served in the Pacific theater and who had found the islands so inviting, it was reminiscent of the universal idea of a paradise lost and the loss of innocence. It also spoke to the lost innocence of America in the face of the bombing of Pearl Harbor and the enormous, terrible undertaking and human costs of World War II. If there was a paradise out there, more than just the servicemen, America itself was ready to find it. And like so many things uniquely American, it began with a song…

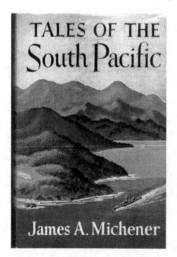

James Michener published *Tales of the South Pacific*, his account of fighting men clowning around between terrifying battles on a small island, just two years after the war. *Penguin Random House, 1947.*

In 1949, Rogers and Hammerstein adapted Michener's book into the musical *South Pacific*. Now the story that had reached and galvanized so many who had gone off to war—some sixteen million Americans—had been lifted up, sifted, reframed for the stage and infused with a glorious collection of songs. When the show hit Broadway, it became an instant hit—garnering enormous critical and box office success. And despite some of its more racially charged themes, it won ten Tony Awards and a Pulitzer Prize, becoming the second longest running musical on Broadway. It also became the bestselling record of the 1940s. Rogers and Hammerstein leaned into

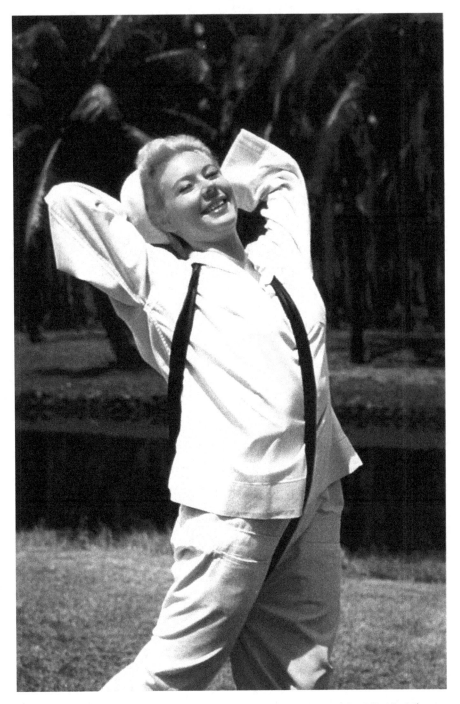

Mitzi Gaynor as the lost-in-love Nurse Nellie in 1958's film version of *South Pacific. 20ᵗʰ Century Fox.*

the most captivating parts of the American experience in the islands during World War II, building on the themes in Michener's book as well as the tropical romance of the Polynesian culture and what it represented, and then set it to music—all for the price of the ticket to the theater or the cost of a record album.

The popular effect *South Pacific* had on America at the time was unmistakable and would only be compounded when it became a film in 1958. But until that time, it was clear that returning servicemen and, in fact, most of America had fallen in love with the romance of the islands and promise of a Polynesian paradise.

All of these things together—the return of Americans from World War II, their exposure to the exotic locales of the islands, their intersection with the Polynesian culture, their feelings of having been on an adventure together and shared something that is uniquely theirs, and then having had a romanticized version taken wide and popularized through dramatization and music—created an atmosphere like no other. We had accomplished something great with the winning of the war but had been expelled from paradise in the process. We had been on a great adventure. Perhaps the greatest ever—for the right reasons—and yet, there were no more great adventures to be had. On the other hand, the experiences that we had shared were now the stuff of books and musical theater—very much alive in the minds of the popular culture of the time.

Thor Heyerdahl writes:

> *Sometimes, too, we went out in the rubber boat to look at ourselves at night. Coal-black seas towered up on all sides, and a glittering myriad of tropical stars drew a faint reflection from plankton in the water. The world was simple—stars in the darkness. Whether it was 1947 B.C. or A.D. suddenly became of no significance. We lived, and that we felt with alert intensity. We realized that life had been full for men before the technical age also—in fact, fuller and richer in many ways than the life of modern man. Time and evolution somehow ceased to exist; all that was real and that mattered were the same today as they had always been and would always be. We were swallowed up in the absolute common measure of history—endless unbroken darkness under a swarm of stars.*

Heyerdahl's book may not have been the straw that broke the camel's back, but it certainly provided something that was needed—a pop culture icon who was on a grand adventure of his own, doing the things that we longed to do.

The addition of an actual individual to the mix—one we could see and touch and talk to, read about his experiences, "go" on his adventures—created a fervor that might otherwise have not been achievable. He was the catalyst that lit the volcano of the pursuit of the Polynesian dream.

Much like I was catapulted far across the sea to ride the waves with him, Americans were captivated by what he was doing. Yes, he was searching for answers to his theories, but in so doing, he was searching for his own paradise. Michener explained:

> For the Polynesians, "Hawaiki" represents their traditional homeland—a place that they came from and the place that they will go again when they die. It is their Paradise. Tiki—or Tiki Tiki Tanata—is the image of a person, a god, the strongest form of something to pray to.

This is the reality. Americans of the '40s, however, were desperately in love with the romance of the islands, fantasized about Polynesian culture and were captivated by the charm of its people.

The Tiki soon became synonymous in America with an imaginary version of Polynesian culture, not just part of the equipment of the experience but

Tiki Tumblers amid a Hawaiian lei. *Julia Guzman.*

emblematic of the way of life. Like with most things, the media had allowed the ideas and shared experiences of island life to propagate and intermingle with the American experience—so much so that, after a while, most people had very little clear memory or even firsthand exposure to what life in the islands was really like. But what we did have was a beautiful image, a dream, a fantasy, of everything the Tiki lifestyle could offer us. We were hooked.

And like a wonderfully crafted cocktail, we drank it down.

I

Going Native, California Style

I wish I could tell you about the South Pacific. The way it actually was…Bali Ha'i was an island of the sea, a jewel of the vast ocean.…From two miles distance, no seafarer could have guessed that Bali Ha'i existed. Like most lovely things, one had to seek it out and even to know what one was seeking before it could be found.
—from the novel South Pacific *by James A. Michener*

From its humble beginnings in the minds of servicemen returning to civilian life, Tiki began to take root on the mainland in post–World War II America. It was a fertile time, as the United States began to rebuild—its society, its infrastructure, its standing as a global leader. But even as fleets of planes, trains and buses deposited America's young men back on rolling farms and into generations-old factory towns, those who returned could not help but feel changed by what they had seen and experienced. They shared an unbreakable bond, one that had come from seeing the worst that mankind and technology had to offer, the ugly side of modern society, armed conflict on a global scale, mechanized warfare that resulted in catastrophic loss of life and socialized systematic genocide. But they were also bound by what they had witnessed firsthand and collectively romanticized about island living in the Pacific. This was the good life. Easier. Captivating. Alluring. The natives there simply didn't have the same cares and burdens that Americans had. Surely, their lifestyle was *the* antidote to the problems caused by the corruption of war and modern life in the twentieth century.

The eighteenth-century Enlightenment philosopher Jean-Jacques Rousseau wrote that original man was actually freer of sin than our modern brethren and indigenous people were not brutal savages, but peaceful, and should actually be considered noble—uncorrupted by civilization and representative of humanity's innate goodness. This noble savage idea was echoed numerous times throughout the modern age, but for those who had seen what modernity had to offer in wartime, there was an unalienable truth to it—one that provided solace, comfort and refuge to the world-weary and disillusioned. More to the point, life in the islands was far better than what Americans had seen on the beaches and jungles of Iwo Jima and Bataan—even in the cities of Berlin and Paris, promising a slower pace to living—one of peace, tranquility and endless natural beauty. So, with its sailors returning home and newfound prosperity in the wake of peace, the United States found itself primed for a revolution of a different kind. A *Tiki revolution*. And there was no better place to kick one off than on the beaches and cities of California.

Until Hawaii's admission to the Union in 1959, California was America's closest thing to island living. California had always been built on dreams, starting with the gold rush in 1848, but now it provided the exact right environment of surf, sand and sun for the simulacrum of island life—and Tiki—to flourish. California could be the place where Americans could replicate the ideal life they had witnessed in the Pacific and fabricate an environment where they could be free of their obligations and let off a little steam. A place where they could let loose and go a little native.

Sex also played a role to be sure. But again, building on the writings of both Rousseau and Michener and the social norms of the day, the promise of the native girl as confessor confidant was a heady cocktail and the key to release for the sexually repressed males of the 1950s. More than that, though, she was the focal point for this movement—the "Wahini in Waiting." It was through her that the promise of island life and that of Tiki quite literally had legs. She was the antidote to Puritanism—the embodiment of freedom but still somehow innocent and unspoiled. If anything, she was an opportunity to misbehave that American men (and America) longed for. She was a lovely fantasy, necessary at the time—an escape by definition—but so was the Tiki that she represented. If they were escapes, however, they were certainly glorious ones that captivated a generation, launched a lifestyle and propagated a modern American myth. And nobody knew more about escapism than California.

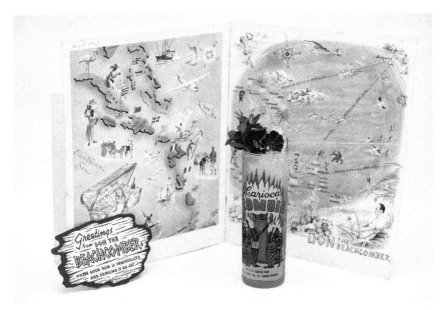

The menu of LA's Don the Beachcomber, the bar that played a vital role in the creation of Tiki culture. *Wikimedia.*

To practically everywhere else in the United States, California was already a made-up place. A dreamy spot of sun-drenched coastline and gorgeous days. This went double for Los Angeles and especially Hollywood, where actual dreams were made and exported all over the world. It just so happened that this paradise was also perfect for a tremendous number of returning servicemen to settle—many of whom shared a love of the islands and longed for an escape.

Enter Donn Beach and Trader Vic.

Donn Beach—whose real name was Ernie Gantt—was once a bootlegger during the Prohibition times of the 1930s but then moved to Hollywood and opened a bar. His Polynesian-themed place was already something of a draw to people in a town that loved a good story. But Ernie Gantt saw a deeper opportunity. Taking the cheapest alcohol available to him at the time—rum—Gantt created what he called "Rum Rhapsodies" and served them in his bar. He also cultivated largely Cantonese dishes and turned them into adventurous, exotic cuisine. So unusual and out of the ordinary were his drinks and dishes—and in fact, the entire drinking and dining environment—that Gantt's Don the Beachcomber was frequented by many celebrities in Hollywood, adding to the popularization and explosion of the California Tiki movement.

Victor Burgeron Jr., also known as Trader Vic, saw what was happening from San Francisco and, employing a staff of Filipino bartenders, continued to expand on the variety and flavors of Tiki drinks available to enthusiasts. He is largely credited with the creation of the Mai Tai—a staple in the Tiki catalogue of drinks. However, like with Gantt, Burgeron's drinks, décor and food weren't truly Polynesian (Rum isn't even an alcohol that was used in drinks there. It's far more Caribbean.), but he was selling the idea of the Polynesian influence. Moreover, it was this mix of cultures and Seven Seas adventure that really sold the escapist part of the experience. It fueled the fantasy. Once again, Hollywood was attracted. Burgeron expanded to multiple locations, and Trader Vic's became the hot spot for the Hollywood elite.

These two men had tapped into the rising desire for escape, the need for Americans of the time to be transported somewhere exotic, somewhere exciting—somewhere else. They had also cracked the code of cultivating and packaging that experience in a dark, tropically themed environment, serving sweet and strong exotic cocktails and cuisine about as far away from tuna casserole as the North Pole is from the South. They did all of this—and managed to put that experience in the hands of people for only a few dollars.

Together, Donn Beach and Trader Vic singlehandedly created "Dining as Entertainment." The rest of the United States couldn't help but follow. Soon, a vast tidal wave of Tiki-themed restaurants and bars flooded America and beyond. It was as if these two giants poured rum on the fires of the Tiki revolution—literally using the wood from the *Kon Tiki* itself—and with Hollywood's help, set the whole country ablaze.

As with Bali Ha'i, Tiki satisfied a yearning that many people collectively had inside. It was something they shared, but it was also deeply personal. However, their desire to seek out their own escapes didn't stop at going out for dinner and drinks. People wanted to have a direct connection to the experience itself—to access it anytime, to own it. They wanted it in their homes. The backyard luau was born.

In the islands, the luau is a communal event of great celebration, involving music, dance, stories and feasting. The resources of the entire village were pooled; every family was represented, and the gods were honored. In America—and in California specifically—the backyard luau was still very much a feast event, with any number of Tiki-themed food and drinks, but it was much more of a statement. On the one hand, the food, music and décor still very much flew in the face of the still-prevailing conservative values of

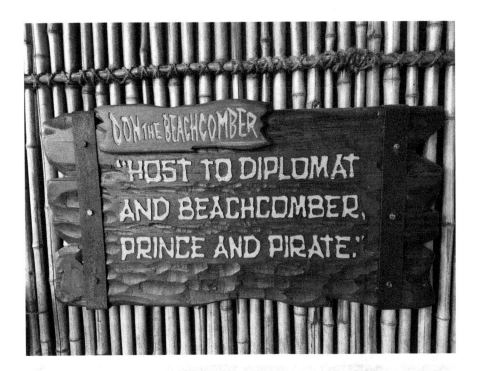

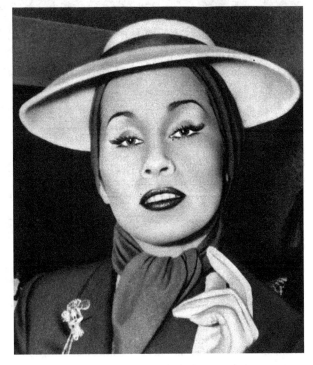

Above: The mantra of Don the Beachcomber, as posted on the door. *Jason Henderson.*

Right: Yma Sumac, diva of Exotica music, in Italy for a tour date in March of 1954. *Wikimedia.*

the time. On the other, nothing said success like a backyard or office luau—it was the perfect subversion.

To support these events, an entire industry rose. Martin Denny's music, though "fictionalized" by his account—with its animal calls, volcano rumbles and jungle sounds—incorporated certain ethnic sounds and instruments. This psychedelic fusion—called Exotica or sometimes "Pagan Pop"—became a soundtrack mainstay of backyard luaus, exotic dens and island living rooms. So legitimate and connected was Denny to this movement that James Michener actually wrote the liner notes for Denny's album *Hypnotique*. The luau rental business also boomed—carved Tikis, drums, torches, costumes and island art were available at a moment's notice.

In 1956, Bob Van Oosting and Leroy Schmaltz spent time learning island crafts in Tahiti and New Caledonia and then formed Oceanic Arts in Whittier, California. Together they provided rental and retail tropical designs for Trader Vics, Don the Beachcomber, Disneyland and a thousand other Tiki bars, restaurants, locations and film sets worldwide. They also served as the go-to spot for people in California who wanted Tiki, tropical and Polynesian decor in their homes.

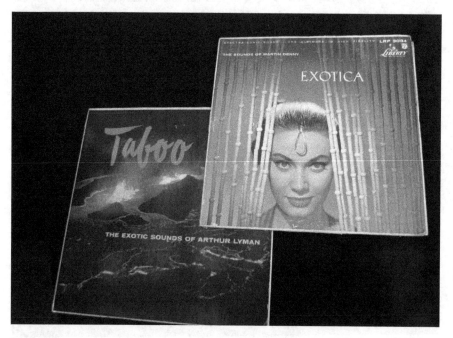

Two of the masterpieces of Tiki music: Martin Denny's *Exotica* (1957) and Arthur Lyman's *Taboo* (1958). Lyman was a wunderkind who played vibraphones for Denny before breaking out on his own. Together they made Exotica into a recognizable sound and brought the imaginary jungle paradise into American dens. *Liberty Records and HiFi Records.*

Wooden masks displaying Tiki motifs. *Julia Guzman.*

As luaus grew more frequent, these parties became something of a fixture of American life. It was a style—an aspect of design. And whether it was appropriated culture or not, Tiki had been woven into the fabric of the American success story—and people wanted it year-round.

As the '50s and '60s progressed, Tiki became even more sophisticated and sexy. Art took the form of velvet paintings, and midcentury space-age modern architecture took on Polynesian influences—particularly in what would later be the swinging bachelor pads that dotted the landscape in LA.

Finally, when Hawaii became a state in 1959, Tiki design, Tiki Culture and Tiki tourism exploded. In fact, Walt Disney was so taken by Tiki—its adventure themes and its impact on American culture—that he opened the Enchanted Tiki Room in California's Disneyland in 1963. Hugh Hefner even hosted a Tiki event on his *Playboy After Dark* syndicated television show, which was broadcasted coast-to-coast into peoples' living rooms. And if anything held true to the alluring escapist qualities and playful sexiness of Tiki's promises while delivering on the style and sophistication of the time, it was Playboy and Hef.

So what had once been planted by Michener and South Pacific, fertilized by World War II and watered by the potent cocktail of rum and the media now produced a thriving pop culture phenomenon called Tiki. On the sunny hills of California, America had gone native and was loving every minute of it.

Tiki and The Man in the Gray Flannel Suit

Although not a heavily Tiki-themed story, no work captures the context of Tiki Culture more than *The Man in the Gray Flannel Suit*, a 1955 bestseller by Sloan Wilson and a Gregory Peck–starring movie about the alienation of middle class life in post–World War II America. Specifically, the book (the model for the television series *Mad Men* years later) concerns itself with the portion of the population that had served in the war. *The Man in the Gray Flannel Suit* is the key to understanding Tiki Culture.

In the current era, soldiers make up a small percentage of American citizens—a "loyal one percent" of citizens who enlist. By contrast, World War II demanded a staggering commitment. Some 9 percent of the total U.S. population fought in the war—16.1 million Americans, with 405,000 deaths and 672,000 wounded. World War II was "total war." At first, the draft—the legal means by which the U.S. government ordered able-bodied men into service in the armed forces—committed men for only one year, but the demands of conscription grew. After Pearl Harbor, every man fit for duty was conscripted for the duration of the conflict. "For the duration" meant that when a man survived one battle he went back to another, as Paul Fussell observed, "for the duration of the Germans' [and] Japan's pleasure."

And then in 1945, it was over, and the sixteen million came home. *The Man in the Gray Flannel Suit* is about one such man, Tom Rath, who at the start of the book is nearly ten years out of the war and still thinks about it constantly. When asked to write a brief autobiography as part of a job application for a public relations position, he considers finishing the prompt "the most significant thing about me is" with "I killed seventeen

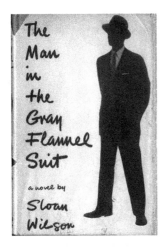

Ad man Sloan Wilson's 1955 novel *The Man in the Gray Flannel Suit* explored the inner life of men who carried psychic scars from the war. The need to contextualize those horrors is a key ingredient of Tiki Culture. *Simon & Schuster.*

men." But of course he doesn't say that. It's 1955, and most everyone around him also served. Perhaps among the people who ride the commuter train with him every morning are those who also had to (as we learn) slaughter young enemies for their coats or accidentally blow up their friends while being shelled taking a South Pacific beach. Perhaps his story isn't that unusual at all, which for Tom is part of the horror of the thing.

Tom snaps back and forth between *then*, in the European theater, with its freezing cold tortures interrupted by long periods of romantic dawdling, and the South Pacific, where his service was terrifying and brief, and *now*, 1955, where he would like to get a better job and maybe a better house.

The Man in the Gray Flannel Suit hits three themes repeatedly: the need for men like Tom to find a place and purpose in postwar life, the need to repurpose or contextualize the agonizing experiences of the war and the vivid haunting of romance that "escaped time" during the war. Tiki Culture was an expression of each of these themes for the same group of people.

FINDING ONE'S PLACE

Tom Rath is paralyzed by the need to find a place among the "men in the gray flannel suits" who inhabit New York City. But he doesn't particularly like what he sees—men who train to hide their opinions until they can advance by agreeing with the men above them, on and on in vast organizations. Tom said,

> *I really don't know what I was looking for when I got back from the war but it seemed as though all I could see was a lot of bright young men in gray flannel suits rushing around New York in a frantic parade to nowhere. They seemed to me to be pursuing neither ideals nor happiness—they*

were pursuing a routine. For a long while I thought I was on the sidelines watching that parade, and it was quite a shock to glance down and see that I too was wearing a gray flannel suit.

His mentor in avoiding such moral death is his wife, Betsy, who tells him she is ashamed to see him grow cynical. Betsy Rath could be the target audience for a speech given in 1955 by Adlai Stevenson at Smith College, who saw the threat to the sanity and moral fiber of American men. The men of America were soldiers who had learned "the means" very well: Do your duty. Find a job. Go there and work late and say yes when asked for a yes:

This typical Western man, or typical Western husband, operates well in the realm of means....But outside his specialty, in the realm of ends, he is apt to operate poorly or not at all. And this neglect of the cultivation of more mature values can only mean that his life, and the life of the society he determines, will lack valid purpose, however busy and even profitable it may be.

In a memorable harangue in the book, Betsy diagnoses Tom and by proxy all American men as essentially running scared through modernity:

You think you're something special because a hell of a long while ago you were a good paratrooper. And now all you want is security, and life insurance, and money in the bank to send the kids to college twelve or fifteen years from now, and you're scared because for six months you'll be on trial on a new job, and you always look at the dark side of everything, and you've got no guts!

In the end, Tom begins to find his new place and purpose: for him, it's spending time with his family as a "9 to 5" man instead of spending the twelve or fifteen hours a day working, as modeled by his employers. All of this becomes clear when he begins to be honest, both about his present opinions and belief and his past in the war.

Tiki Culture sought to answer Tom's need by way of allowing the Man in the Gray Flannel suit to create a new place among familiar surroundings. In *Tiki Style*, Sven Kirsten describes all the accoutrements of a new Tiki bar:

- A-frame construction
- A bridge to cross into the body of the restaurant or bar
- Jungle foliage everywhere
- Masks and weapons on walls

The "floor-to-ceiling" use of "exotic woods, bamboo, rattan, tapa cloth [etc.]" plus dioramas and "white beachcomber lamps" created a recognizable "uniform" for relaxation and entertainment. It's the equivalent of the gray flannel suit itself—Tom thinks it to be "the uniform of the day....Somebody must have put out an order."

The design of Tiki was patterned, like Exotica music, after the South Seas but never precisely like any one. It was a design that reminded the returning soldier of his time in a variety of environments overseas. But it fits neatly in with his chrome, industrial life, and it has a door that can shut.

Repurposing Memories of War

The war is constantly with Tom, and *The Man in the Gray Flannel Suit* finds Tom needing to repurpose the lessons learned and pain he endured there. The problem, Tom later says when he's being honest, is that America employs citizen soldiers. "One day," Tom says, "a man's catching the 8:26, and then suddenly he's killing people. Then a few weeks later he's catching the 8:26 again." Tom tries to make sense out of the madness—that he could endure bombs going off around him and accidentally blow his best friend apart—all of that being expected and accepted, and then he's expected to come back and put it all away. "We're all nuts," he tells his friend on the way from one theater of war to another.

One way Tom overcomes his nervousness or fear about one piece of business or another is remembering what he always told himself before he jumped out of an airplane, a sort of "magical incantation": "It doesn't matter. Here goes nothing. It will be interesting to see what happens." In so doing, he repurposes the skills he learned in times of physical crisis to stateside times of mental crisis. His mantra enables him to take risks again.

In fact, Tom's method of coping (dissociating himself from the danger) was common for a time when there was great stigma attached to admitting mental vulnerabilities. Tom and his fellow GIs were expected to get over it. According to Michael C.C. Adams,

> *Magazines promoted the idea of a quick fix,* Good Housekeeping *telling lies that they should stop "oppressive remembering" in 2 to 3 weeks. Even the Army in its 1946 educational documentary* Let There Be Light *predicted most men should be doing well in 8 to 10 weeks.*

In *The Man in the Gray Flannel Suit* (1956), Gregory Peck strives to succeed in the expanding American economy while dealing with the guilt and horrors of his experiences in World War II. *20ᵗʰ Century Fox.*

But they weren't getting over it. Instead, combat veterans tamped down their feelings and sedated themselves:

> *Trying to repress feelings, they drank, gambled, suffered paralyzing depression, and became inarticulately violent. A paratrooper's wife would "sit for hours and just hold him when he shook." Afterward, he started beating her and the children: "He became a brute."*

The use of alcohol, always a steady pastime, became central to postwar life, with the "martini lunch" and "cocktail hour" taking prominent place. Adams's book reports that the marital strife of Tom and Betsy all too

commonly ended in divorce, with divorces among World War II veterans under age twenty-nine reaching "1 out of 29, as compared to a general rate of 1 in 60."

The great strangeness of Tiki Culture was its aesthetic similarity to some of the most beautiful yet haunting geographies of the war. For Tom, the South Pacific was the place where he landed in battle and ran through shelling (which Paul Fussell called "not fighting but suffering") and accidentally blew his friend apart. Tiki created a popular space where men like Tom, wives like Betsy, women who served as WACS and medical personnel would find entertainment in surroundings that looked like the most vivid moments of their lives. It tamed those lurid memories and turned them into something like a dream.

In *Tiki Pop*, Kirsten posits that "when shell-shocked vets returned home, no one really wanted to hear stories of bloodied corpses and blown-off limbs. Eager to return to normal life, the GIs themselves willingly forgot about the horrors of battle." In the first instance he is right: men like Tom did not discuss and others did not want to hear of his pain. But in the second instance, it might be more correct to suggest that rather than "willingly forgetting," the veterans sought to sublimate their experiences, to control them and transform them into something new. They could easily have pursued a style of chrome and concrete, but they deliberately opted for a world that mirrored their worst nightmares.

TIMELESS, ROMANTIC MEMORY

Finally, *The Man in the Gray Flannel Suit*, like *South Pacific*, deals with a subject that may be even more uncomfortable for Tom and the reader than the memories of killing: the memory of romance. While in Rome, Tom waited for orders to ship out to the South Pacific for six weeks. In that time, certain that he would soon die, he met and moved in with Maria, a fragile, beautiful Italian girl whose parents burned to death before her eyes. They live lives of immediacy and sensuality, singing songs and making love, having picnics in blasted old ruins. Time stops for Tom and Maria, and Tom finds that he lives only for the present.

This strange suspension of time recalls the characters in James Michener's *Tales of the South Pacific*, waiting for action on a small island and concerning themselves with gambling and chasing nurses. The South Pacific, which

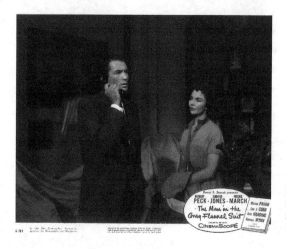

Gregory Peck is haunted by a short-lived wartime love affair in *The Man in the Gray Flannel Suit* (1956). *20ᵗʰ Century Fox.*

could explode with mortars and blood in an instant, is suspended between those moments as a paradise of palm trees and coconuts. For Tom, the blasted remains of a castle in which he and Maria picnic are beautiful, as though the ruin was *always* a ruin and the world will go on forever. Maria wants to be touched and held, for she can be comforted by no thought of future or past. The war has made Tom, Maria and Nellie of *South Pacific* into people running from the next moment, aware that they are always trying to stall death.

In the postwar United States, Tom has no such romance. Every moment is spent either trapped in a remembrance of the grisly or beautiful past or terrified of failure in the future. Tom and Betsy are finally able to rekindle romance and break free from Tom's paralysis by embracing risk and honesty. Tom tells Betsy that he has recently learned that he has a son by Maria, and he wants to begin to make support payments. His romance of the past has always haunted him, but now he can put it in context and grapple with it today. His son is a part of today, like the job in the city and Tom's and Betsy's hopes of starting a new business on their own.

Tom's son is a fictionalization of a very large, very real problem. *Stars and Stripes* had to dedicate an article to advice on how to arrange for (or not) the welfare of one's offspring in occupied Germany, where thirty-six thousand out of sixty-six thousand illegitimate children were the children of American soldiers. And that's after the end of the war: prior to that, numbers vanish. Back in America, the predominant suburban culture didn't lend itself to flights of romance. Illegitimate children left in Europe were of a piece with the horrors experienced in the same place: things to be hidden and only occasionally whispered about.

Tiki Culture provided a sublimation of the immediacy of death and romance in the war, funneling horror and romance into a kind of ritualized entertainment that could be taken down off the shelf and spun around and then put back.

Tiki Culture was all about recreating the romance of the South Pacific in a nonspecific way. In the same way that Tom's love affair in Italy made Tom forget time, Tiki Culture suspends the bar customer or backyard lounger in a place completely outside modernity and geography. In the same way that France, Italy, Germany and the South Pacific were a long train of one place after another where the GI had little time or tools to tell them apart, Tiki environments create an equally unique and untethered space. Tiki spaces are romantic in the way that Tom found romance when time was frozen, but Tom's surroundings created that opportunity automatically. Men had to build Tiki spaces to recreate that suspension of time and place.

In his Smith College speech, Adlai Stevenson remarked that "collectivism in various forms has collided with individualism time and again. This twentieth-century collision, this 'crisis' we are forever talking about, will be won at last not on the battlefield but in the head and heart." Tiki spaces and Tiki music were a powerful means to an end: the healing of wounded people trying to reorient themselves in American society.

3
Tiki Music

Martin Denny, Les Baxter and Exotica

THE TIKI SOUNDTRACK: EXOTICA OR SURF?

Think of the Tiki bar we're building in our minds. What kind of music is playing? Most likely, you'd choose one of two answers: Exotica music or surf music.

Today, if you walk into a Tiki bar, such as the current iteration of Don the Beachcomber in LA, the music you're likely to hear is surf music, a kind of instrumental rock created in the '60s by artists like Dick Dale and the Ventures. Surf music fits the Tiki scene very well, and we're going to explore the origins of this fascinating sound.

But before surf music became the de facto soundtrack to Tiki, one style above all defined the Tiki movement. If you walked into a Tiki bar or a Tiki-themed rec room in the '50s and '60s, the sound you were likely to hear was Exotica.

Exotica, which enjoyed immense popularity roughly from the time of the Korean War to the end of the Vietnam War, was the music of "plants and palm trees," the "mood music of place but no place familiar." It was intended to be *exotic* in the true sense of the word—derived from the Greek for *outside*, incorporating "foreign (or at least strange-sounding)" elements.

Musicians of the era took the basic sound of jazz and big band and infused it with sounds that would make the listener—generally assumed to be the suburban American—feel as though they had been transplanted to

a foreign land. Exotica "relied heavily on percussion: conga, bongos, vibes [vibraphone], gongs, boo bans (bamboo sticks), Tahitian log, Chinese bell tree, etc." "Hawaiianesque" elements like ukulele, steel guitar and wind instruments borrowed from the music of "Polynesia, Melanesia, Micronesia and Southeast Asia" and brought in Afro-Cuban and Greek rhythms.

Add to that the "essential signature of musical Exotica"—the bird call. Martin Denny started adding what sounded like animal and bird noises with his earliest recordings, completing the illusion of an outdoor space stuffed with lush greenery and teeming with wild life. This was an innovation that differed from how instruments had been used to suggest living entities inside the music before, such as the piccolo piano in *Peter and the Wolf*, which "played" a bird, and was more like the singular use of a cannon in the *1812 Overture*, which not only sounded like a cannon but also "played" a cannon. These are sound effects that complete the illusion. If you listened to Bing Crosby, you would see yourself as a person in a living room listening to Bing Crosby—a person listening to Exotica was expected to be transported somewhere else.

The result, still timed and tuned to appeal to Western ears, was a soundtrack without a movie, the soundtrack to the leisure life of the man in the gray flannel suit as he moved through his retreat paradise.

Shuhei Hosokawa identified three aspects of Exotica:

1. Geographically, Exotica focuses specifically on the South Pacific, the "Orient" and on islands in general (rather than on continents and deserts).
2. Aesthetically, it is orientated more toward mood and effect than toward structure and thought.
3. Epistemologically, it comprises a fantasy of travel, an aural simulation of imagined experience of transport to exotic lands (an aspect of which is intended to relax listeners).

Just as Exotica is not surf music, we can also distinguish it from related movements like Polynesian music, which more accurately tried to capture the sound of Hawaii, with proponents like steel guitarist Bill Sevesi. If a movie takes place in Hawaii, the sound you hear is likely to be "Hawaiian" or Polynesian music. Exotica tries to sound like no place real.

Above all else, Exotica was not ironic, not "pseudo-exotic" or pseudo-anything. It was an earnest attempt to create a mindscape into which the listener could escape. Philip Ford noted that "to complain that...Exotica is inauthentic is to miss the point."

It's authentically exotic, authentically a sound that suggests a place far away.

The idea of music that sounds like no real place but *suggests* far-off places of romance, adventure and relaxation poses a question: is it okay to like this stuff? Contemporary writers grapple with this discomfort with the appropriation of so many sounds because the result is music that assumes a distinctly Western, American, white ear. Philip Hayward writes that to ethnomusicologists, whose business it is to know what real music from real places actually is, Exotica sounds "so irredeemably kitsch" that it defies listening to it except as an ironic or disinterested observer. But someone *wrote* this music, someone listened to it enough for it to top the Billboard charts and the music today is still available for Tiki enthusiasts to review for themselves.

Exotica died the way Tiki did, in the wake of the Vietnam War and hippie culture. Tiki music topped the charts for a finite period that began with the end of World War II, when the members of the Greatest Generation were at the height of their buying power and still drove American tastes.

But by the late 1960s, pop culture was being led by a new generation—who couldn't be expected to wholeheartedly embrace their parents' music, whatever their own preferences. The Woodstock generation's rejection of Exotica was total and distinguished by major differences. The hippies sought to express themselves in a way that went "back to nature," as evidenced by leather clothing and fringe (a look borrowed heavily from Hollywood depictions of Native Americans). Exotica, by contrast, suggested the listener was *surrounded* by nature but only visiting—it remained an escape *outside* cultural norms. Exotica always spoke to a people who embraced the booming postwar economy and wanted to spice it with foreign-seeming sounds. They would never have rejected the establishment completely, and the music was always an escape.

Hosokawa noted that by the end, with Exotica appearing in covers of "Blowin' in the Wind," what had been a signature sound of the faraway place had become not exotic at all: it was just another way of arranging pop music by the establishment. Phil Ford writes that Exotica music "both represents taboo and enacts it" because it challenges our demand for a specific cultural context for music, and the lack of knowing is a taboo in itself. For a time, that taboo held America transfixed. By the late 1960s, it was the music of a new generation's parents and grandparents, and like all generations, it passed on.

TOP EXOTICA ALBUMS

A complete review of Exotica music would be near-impossible, but there are standouts to the genre that would make a fine collection for the new Tiki enthusiast.

Les Baxter, Ritual of the Savage (Le Sacre du Sauvage) *(1951)*

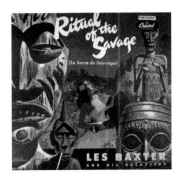

Les Baxter, *Le Sacre du Sauvage*
(1951). *Capitol Records.*

Of all Exotica albums, *Ritual of the Savage (Le Sacre du Sauvage)* is the most celebrated and deserves a complete tour. Les Baxter's *Ritual* has been called the first true Exotica record and precisely illustrates Phil Ford's theory that the best Exotica is a soundtrack to a movie in your mind. Rather than an album of loosely connected tracks, *Ritual* is an instrumental journey from civilization to the most secret realms of the exotic. It even follows a filmic storytelling rhythm, with thresholds to cross, act breaks, romantic interludes and a final climax in a new locale. The album begins at a "Busy Port," which sounds like a 1940s background for "industry on the march!" One can picture the hero's boat being readied, dockworkers scurrying hither and thither with goods and foodstuffs for the journey. Once underway, we ride the "Jungle River Boat," with woodwinds and chimes suggesting wildlife on the shore as piano sets a rapid pace. Then Baxter gives us a first romantic interlude: the "Jungle Flower" appears—is this a nickname for a beautiful fellow passenger on the journey, an "exotic" guide, or both? But soon we pass our first threshold of the secret deep—the "Stone God," a rapid and percussive piece in which we first spot a sign of hidden civilization. As in an adventure film, this is an early thrill, not the final destination, because no sooner have we passed the god than we arrive at the "Quiet Village."

"Quiet Village" is a benchmark piece in Exotica; everyone records one. (In this book alone, we'll mention at least three.) Baxter's "Quiet Village" is a lush, orchestral recording in which strings carry the melody. This is the village of rest, where our hero meets allies and rests before moving deeper. Soon we're underway on a comic "Jungle Jalopy," rattling deeper into the jungle as woodwinds warn us in the background of looming danger.

The last four tracks tell the story of what happens when we reach our deepest destination: the hidden realm where a "Coronation" is underway, and as the new ruler watches, a "Love Dance" proceeds with the first prominent vocals. We are witnessing rituals not meant for Western eyes. Once again Baxter changes up the story with a comic break, the sambaesque "Kinkajou," named after the small rainforest mammal. And then comes "The Ritual," heavy with "native" chanting and a driving percussive rhythm. This is the end of the journey in the original album—we are not made aware whether our hero returns.

The liner notes explain exactly what the album is supposed to be up to:

> *Here, for the first time, rhythms and musical sounds of the secret and high orders of native tribes are used to transform the jungle mat into a colorful stage for the violent emotional expressions of these mysterious and primitive folk.*

The Cover

Ritual of the Savage has one of the most striking Exotica record covers and sets the tone for Exotica albums to come. The eye is first drawn to a prominent idol in the foreground amid lush jungle undergrowth. Three more idols complete a sort of barrier around our main characters—a pair of Western lovers in evening dress in a passionate tango-like embrace. *You* are the lead. The movie of jungle mystery is playing around you.

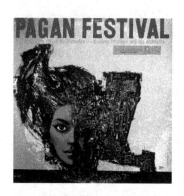

Dominic Frontiere, *Pagan Festival* (1959). *Columbia Records.*

Dominic Frontiere, Pagan Festival (1959)

Dominic Frontiere was an American composer best known for the theme songs for television series like *The Fugitive, The Outer Limits* and *The Invaders* as well as Hollywood films into the mid-1990s. Though largely forgotten today, Frontiere's 1959 album *Pagan Festival* is a prime example of Exotica. Taking cues from *Ritual of the Savage, Pagan Festival* (subtitled *An Exotic Love Ritual for*

Orchestra) calls on Frontiere's skills as a soundtrack composer to create a soundscape of (if we believe the liner notes) an "interpretation of ancient Inca rituals, superstitions, and the romance and mysteries of their colorful civilization." Tracks like "Venus Girl" are much more Hollywood romance than Exotica, but certain tracks, like "House of Pleasure" and "Jaguar God," deliver what the Exotica listener has come for, an odd blend of modernity and (imagined) antiquity.

Writing for *AllMusic*, William Ruhlmann said of the album:

> *Of course, somewhere in there, Frontiere also found use for his own chosen instrument, the accordion. Did the Incas play accordions while performing their pagan rituals? Perhaps not. But Frontiere's music charmed like a particularly entertaining Hollywood score for a movie set in some faraway place, but shot on a backlot. It may not have been historically accurate, but it was a lot of fun to listen to.*

The Cover

Whereas *Ritual of the Savage* went with a clear collage of images, *Pagan Festival* employs a modern painting from Irene Trivas, who painted many striking covers in the '50s and '60s in addition to providing illustrations for children's books. Here we see in close-up the head and neck of a woman (perhaps the "Moon Goddess" essayed in one song, perhaps the "Venus Girl") with a wild headdress/scarf festooned with jewels and knitted through with odd shapes. On the woman's right side (the left side of the image) the scarf swoops up and seems to lose its form to become a stroke of artistry alone, the solid melting into the conceptual. The dark-complexioned woman, whose cheeks and lips are tinted with pale purple, stares at us patiently with large brown eyes set off with bold eyeliner and sculpted, modern eyebrows. The image of the woman enveloped in the mysterious scarf is the entire picture. The beautiful woman in the image calmly invites us to a ritual that is flowing from reality to fantasy.

Yma Sumac, Voice of the Xtabay *(1950)*

Rebecca Leydon asserted that "Yma Sumac's *Voice of the Xtabay* (1950) and Baxter's *Ritual*...inaugurated a nation-wide Exotica craze." But while Les

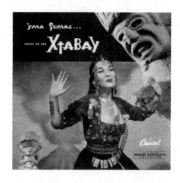

Yma Sumac, *Voice of the Xtabay*
(1950). *Capitol Records.*

Baxter in his own recordings made Exotica that sounded like a Hollywood soundtrack, *Voice of the Xtabay* is something else entirely—a collection of songs influenced by Peruvian music, all accompanied by Sumac's powerful voice. The album sets out to introduce us to songs that weave "fragments of traditional themes, native chants and forbidden ritual into tapestries of sound that are as fresh, new and exciting as the beautiful Yma Sumac who sings them." What's remarkable is that Les Baxter is the writer behind this album as well, taking Sumac as his muse and creating an album unlike his own.

Born in Peru as Zoila Augusta Emperatriz Chávarri del Castillo, Yma Sumac came to the United States with a talent for Peruvian songs and a vocal range that composer Virgil Thomson placed at "very close to five octaves, but...in no way inhuman or outlandish in sound." Her original home in Peru and most of her biographical data is sketchy before she arrived in the United States in 1942. There she launched her U.S. career as a singer with her composer husband Moisés Vivanco's group, Compañía Peruana de Arte.

Voice of the Xtabay was her debut solo album, a collaboration of Sumac, Baxter and Vivanco. Through the tracks, Sumac alternates between singing in her Peruvian Quechua and colorful vocalizations that soar and drop like bird-festooned waterfalls of sound. The album went to no. 1 on *Variety*'s bestseller list in 1950, with over 500,000 copies sold. Yma Sumac remained a star throughout the Exotica period, playing Carnegie Hall and the Hollywood Bowl. The government of Peru even backed up the claim that she was descended from the last Incan emperor, making her a princess of sorts. Her inherent mystery was such a commonplace subject that Walter Winchell theorized in 1951 she was actually a Brooklynite originally called Amy Camus, and everything else was made up.

Music from *Voice of the Xtabay* appeared heavily in the 1954 proto–Indiana Jones movie *Secret of the Incas,* in which Sumac played Kori-Tica, a Peruvian leader suspicious of Charlton Heston's leather-jacketed, fedora-wearing adventurer.

The Cover

"Sumac is a fearsome sight," proclaimed musicologist Rebecca Leydon, and she is so right: on Sumac's debut album cover, a gray idol gazes down upon Yma Sumac, her arms raised as she looks to the sky. She wears a headdress of gold coins that extends down her neck and a low-cut black dress adorned with gold trim and various baubles. Beautiful and exotic in a world of whiteness, with high cheekbones and dark eyes, Sumac "appears entranced by something somewhere off behind our right shoulder." On her wrists are long gold bracelets. Unlike the models that would appear on Martin Denny's album covers, this is the singer herself, testifying to her own mystery and promising a glimpse at a forgotten, ancient world.

Martin Denny, Exotica (1957)

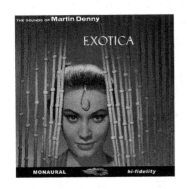

Martin Denny, *Exotica* (1957).
Liberty Records.

Unlike Baxter and his orchestra, Martin Denny recorded with only a quartet: Arthur Lyman (at first) on vibes, Augie Colon on bongos, John Kramer on bass and Denny on piano. "Quiet Village," a Les Baxter composition and the first track on the album, went to no. 1 on the U.S. singles charts. Two differences jump out from the Baxter version of "Quiet Village:" first, while Baxter's orchestral version was led by strings, Denny has the piano do the melody work. Second, it is dominated by a wall of bird sounds.

The bird sounds, an innovation that lets Denny catapult *Exotica* into a kind of aural transport that surpasses Baxter, came as a fluke. Denny, who grew up in Los Angeles, came to Hawaii in 1954 as a musician for the Hawaiian extension of Don the Beachcomber. Soon, Denny's quartet was playing at the Shell Bar at the Hawaiian Village Hotel (the same bar that would feature weekly in the early '60s on the Tiki-infused TV series *Hawaiian Eye*). When the band heard frogs calling during one of their rehearsals, they began to imitate the frogs and then other animals. When they tried this out with the audience, it was a massive hit. Indeed, it is the constant calling of birds—vocalized by band members and meant to

sound like actual birds and not music representing animals à la *Peter and the Wolf*—that establish the "jungleness" of the Denny records.

Denny said of Baxter, "I heard that Baxter didn't approve of the birds. But in time he asked me to send a tape with those verses because he wanted to use them for some of his compositions. I was flattered. The fact is that we were innovators."

Denny attributed the success of the album *Exotica* to the intimacy of his group, saying, "I took at least five or six selections from [*Ritual of the Savage*]; they're imaginative and they fit in with what I did. But he [Baxter] had a big orchestra at his command, whereas I only had four guys, so I had to give 'Quiet Village' a different interpretation entirely. As a result, my version turned out to be the big record."

Indeed, of the twelve tracks on *Exotica*, five are from Les Baxter's *Ritual*: "Quiet Village," "Busy Port," "Love Dance," "Stone God" and "Jungle Flower." But because of the distinct sound of the quartet as opposed to the big band, these songs are transformed into something different. "Love Dance," for instance, sounded jaunty and fun on Baxter's *Ritual*, but here it feels ominous. Strangely, we are out of the "soundtrack" feeling that Baxter brings. Instead, these songs sound like someone has transported the listener and a quartet to the middle of a jungle and handed them contemporary music. This is true Exotica: a constantly confusing feeling of contemporary sound plunged into an ancient surrounding.

The Cover

Exotica features a cover that announces the contrast at play in the music of piano and bird calls. Awash in a soft amber glow, Sandra "Sandy" Warner (who would become the face of Exotica music, appearing on many of Denny's albums as well as others) is a pretty Caucasian with light brown hair, semi-smiling at us from behind a bamboo curtain. She has a silver loop in her hair that hangs down over her forehead—otherwise she is unadorned. We can tell by tufts of hair at the back of her head that her hair has been pulled back, the opposite of freedom and "letting your hair down." She wears prominent eye makeup and red lipstick, also the signifiers of a '50s model. And yet she is on the other side of the bamboo curtain—Sandy Warner is already in the exotic world and is inviting us over to that side, away from the world of American technological advance and into a three-dimensional aural world of a lost jungle.

Arthur Lyman, Taboo *(1958)*

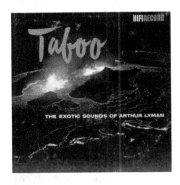

Arthur Lyman, *Taboo* (1958).
HiFi Records.

A wunderkind percussionist who joined Martin Denny's quartet at the age of nineteen, Arthur Lyman was a Hawaiian of Hawaiian, French and Chinese descent. He began playing the vibraphones "at a time of modernization," when Hawaii's identity wavered between the native and the outside world. Although he spent a year with Denny's group—playing the vibes on Denny's *Exotica*—Lyman set out on his own, determined to create a "multi/pan-cultural Hawaiian musical identity." His first album was *Taboo*, and it sold over two million copies.

Lyman recorded *Taboo* and most of his albums at the Kaiser Dome at Hawaiian Village Hotel, where Lyman's band performed nightly. The liner notes explain:

> [Henry J.] *Kaiser's Aluminum Dome is a half sphere, seating about 1500 persons....*[W]*e chose this place for our recording because the half sphere shape has no "peaks" and allows a pleasing "easy" sound reproduction with natural room acoustical reverberation. As you listen you will hear the unique effects produced by moving percussions, giving sound perspective with intrigues. Oh, yes, the ocean sounds heard are real Pacific salt water waves. Native cries are, well, weird but real.*

Taboo shares more with *Voice of Xtabay* than *Ritual* or *Exotica* because Lyman was working to create a new Hawaiian sound, whereas Baxter and Denny were trying to avoid sounding like any place in particular. Lyman's *Taboo* still bears dreaminess and an idea of transportation, but this transportation is to a beachside club in Hawaii with the sea outside. Just listen to the track "Sea Breeze," a cocktail tune that completely evokes Waikiki.

Of particular interest on this album is Lyman's "Misirlou," less ethereal than Denny's strange version, a swinging, Exotica jazz version of "Colonel Bogey's March," and, best of all, "Caravan" done in Exotica style, heavy on bongos and percussions and alternately breaking into straight lounge jazz. There's even the incongruous "Hilo March," a marching band medley that only occasionally veers back to the small-band lounge sound.

Arthur Lyman was a visionary artist who continued to develop and explore new styles, moving into mod jazz and boogaloo, always growing. He played in Hawaii into the 1990s and died in Honolulu in 2002.

The Cover

The cover of *Taboo: The Exotic Sounds of Arthur Lyman* is one of the most naturalistic of Exotica covers. In keeping with Lyman's desire to reference real places rather than imaginary landscapes, Lyman gives us the image of a Hawaiian volcano. There are no paste-ups, only the image with the title and subtitle overlaid on flaming rivers of lava. It is a reminder that exotic places are real and waiting for you, just across the water.

MORE LISTENING

1. Markko Polo Adventurers, *Orienta* (1959)
2. Les Baxter, *The Sacred Idol* (1960)
3. Martin Denny, *Quiet Village* (1959)
4. Martin Denny, "Misirlou" from *Exotic Percussion* (1961)
5. Esquivel, *Other Worlds, Other Sounds* (1958, RCA)
6. Arthur Lyman, *Legend of Pele* (1959)
7. Eden Ahbez, *Eden's Island* (1960)

4
Tiki Music

The Tiki of Surf

In his essay "The Cultures of Tiki," Scott Lukas noted that in modern presentations of Tiki, cultures that had "little or nothing to do with Tiki of the past—like surf culture and car culture—are now becoming a part of Tiki Culture." This is particularly true for surf music, which is now the demonstrable theme music for Tiki bars. If you wander into the new Don the Beachcomber in Huntington Beach or Laguna Beach's Royal Hawaiian, you're much more likely to hear Dick Dale and the Del-Tones or the Surfaris than to hear Martin Denny or Les Baxter. Thus, we must reckon with surf music and its place in Tiki.

Surf music was a movement of generally instrumental, guitar-heavy rock music whose heyday lies almost perfectly from 1960 to 1966. The name reportedly came from a compliment given to the Bel-Airs at a South Bay concert. Champion surfer Lance Carson told Bel-Airs guitarist Paul Johnson that the music was "like surf music." In fact, it had been designed that way: guitarist Dick Dale, who would earn the nickname "King of the Surf Guitar" (although he preferred "The King of Loud"), created the sound that would be defined as surf music when he sought to write songs that would re-create the ratchety, rhythmic sound of water sliding along the underside of a surfboard.

As Dale burned through guitar picks (leaving worn-away picks strewn across the stage after each performance), he adapted the "wrist tremolo" technique to use his whole arm in fast, hard picking:

Surf music, the pounding sound preferred and originated by surfers, dominates Tiki today. *frank mckenna.*

[My technique] *is a heavy, constant machine-gun staccato picking style which puts a very strong accent on the first beat of every measure. This is applying the same sort of physical rhythm to the guitar that you'd apply if you were playing drums. To play this way is very different than the style of most guitar players of today who play with much thinner strings, which are usually used for playing delicate speed scales.*

Dale and his Del-Tones kicked off the surf sound in 1960 while Dale was the house headliner at the Rendezvous Ballroom in Balboa. At the time, instrumental artists like Duane Eddy had enjoyed hits like "Peter Gun," but Dale discovered a sweet spot with his music written to sound like surfing, aimed at a crowd of young people who surfed, gathering at evening parties called (in countless hand-drawn leaflets and fliers) "surf stomps" all along the Southern California coastline.

Surf music was a movement distinctly tied to two determinants: youth and geography. The Sandals' founding member Walter Georis noted, "Southern California was a happy place at the time.…[Surf music] was created by the middle class. The music didn't come from pain—it came from fun." Georis calls out the middle class because the teenage baby

boomers were the first young people to benefit at birth from a massive economic expansion after the end of World War II. Just as Exotica had been an escape from the daily rigors of work and the memories of pain and war, surf was a celebration of a relatively easy life for middle-class white youngsters with time on their hands.

Geographically, surf music was a movement of California: the first two surf records were the .45 singles "Let's Go Trippin'," an ode to adventurous surfing recorded by Dick Dale and his Del-Tones at the Rendezvous Ballroom in August 1961, and "Mr. Moto," recorded in May 1961 by the Bel-Airs, a SoCal high school group led by Richard Delvy.

The year 1962 brought a bumper crop of surf songs, with debut recordings from "The Challengers, The Lively Ones, The Chantays, The Cornells, The Rhythm Rockers, The Surfmen and others." Dick Dale's debut album *Surfers' Choice* came out that year, including "Let's Go Trippin'" and two renditions of a song that probably now stands for surf music more than any other, Dale's surf arrangement of "Misirlou."

Dale would continue to drive innovation, working closely with Leo Fender of the Fender Musical Instrument Company in Orange County. Fender entered the surf music world when Dale approached him for a louder guitar that would handle the acoustics of the Rendezvous well. As Fender rolled out new equipment, Dale and other musicians would "road test" it in front of audiences. The results were the key material for the surf music soldiers: the Fender Stratocaster guitar, the Fender Showman Amp and the Fender Reverberation Unit.

The Reverberation Unit or "Reverb" brought something else: the "wet" sound. Because the Reverb worked by sending sound through a coil suspended in oil, picked guitar sound had a plunking, liquid sound to it that surfers loved. It can be heard very clearly in "Baja" by the Astronauts.

Initially, kids had two places to hear these songs: surf stomps and surf films. Whereas surf stomps were rousing teen-oriented concerts (complete with patrolling policemen enforcing no-drinking rules), surf films were generally more casual affairs. Not to be confused with "surf movies" or "beach party movies," surf films were simply reels of great moments in surfing, usually played at local halls or wherever a screen could be found. Generally, these films were silent, so surf bands would create the soundtrack by playing live. The breakout exception would be Bruce Brown's transcendent soundtrack to *The Endless Summer*, reviewed here.

By 1963, surf music had entered the mainstream, with surf bands making appearances in the kind of films they all professed not to like, the beach

party movies. The same year saw Billboard hits for the Surfaris's "Wipe Out," "Surfer Joe" and "Point Panic," and the Chantays's "Pipeline" (which the band played on *The Lawrence Welk Show*.)

On October 6, 1963, Dick Dale was the first surf musician to appear on *The Ed Sullivan Show*. But the end was not far off. The national mood changed after the assassination of John F. Kennedy a month later, and as with Exotica and Tiki in general, new distaste for the carnage of the Vietnam War took much of the air out of the celebration of American expansion.

A little over a year after Dale's *Ed Sullivan* debut, the Beatles would appear on the same program and usher in a new, melodic, vocal-driven pop sound. From that point on, high school bands started playing Beatles-style music.

Surf music as a nationally notable movement would be swamped.

In fact, it would not be until 1995 with the release of Quentin Tarantino's time-bending film *Pulp Fiction* that surf music would begin a resurgence in earnest, thanks to the inclusion of Dick Dale's "Misirlou" as a theme song.

But why do Tiki bars play surf? Perhaps a first reason is purely a matter of time: Exotica music was the music of the Greatest Generation, while surf music was one of several popular musical movements of the baby boomers. Boomers still remember surf music and are numerous enough (as of this writing) to drive economic development, so their tastes can drive the decision. But this seems an unsatisfactory explanation for the dominance of surf music in Tiki bars, because the bulk of visitors to Don the Beachcomber are not baby boomers. Surf music's victory may owe to the fact that surf music is simply more familiar in general, an accident of the popularity of surf music of the past sixty-five years or so. But would fifteen years make that much of a difference? Exotica's heyday came in the mid-fifties; that of surf came in the early sixties. And both movements had distinctive deaths after their time on the charts.

I tend to believe the preeminence of surf music at Tiki bars has more to do with tempo—it's just peppier. Surf music tends to be driving and intense (with some notable exceptions like the lovely Sandals' *Endless Summer* soundtrack). It's more energetic music, while Exotica tends to be more languid and dreamy, and it may be that visitors to a getaway bar after dinner don't want to unwind that completely.

Top Surf Albums

Dick Dale, Surfers' Choice *(1962)*

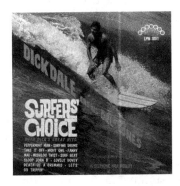

Dick Dale, *Surfers' Choice* (1962).
Deltone Records.

Surfers' Choice includes songs that Dale had been recording and releasing in the years prior, including "Let's Go Trippin'," which rivals the Belairs's "Mr. Moto" for the title of "first surf record."

The album kicks off with "Surf Beat," which introduces both Dale's hard-picking style and his lusty, growling voice. This is true surf music, light on vocals except for the occasional shout.

The song that leads most people to Dale's first album is "Misirlou," whose title roughly means "Egyptian girl." A Middle-Eastern folk song known to Dale through his family, Dale had heard his uncle play the song. Its Tiki associations run deep: Martin Denny and Arthur Lyman both recorded haunting Exotica versions of the song, and "Misirlou" appears on Exotica compilations time and again.

Dale's "Misirlou" was a complete transformation. Supposedly driven by a fan's challenge to play a whole song on a single string, Dale "performed the entire melody on the low E-String, repeated on the high E-string," with Dale accompanying himself on trumpet over the bridge. What had been in Martin Denny's hands an invitation to a strange, foreign land was now one of the most pounding surf songs ever, clearly evoking the chittering sound of water on a surfboard that Dale always sought. Also wonderful is the shouting that Dale does, whooping out as though commanding his band to hit the surf like the Big Kahuna.

Surfers' Choice includes two versions of the song, one called the "Misirlou Twist," which trades the whooping and yelling for strings.

Although Dale has been adamant that surf music is instrumental music, there are, in fact, four vocal songs here in assorted styles. Dale sings "Sloop John B," a Bahamian folk song also known as "The John B Sails" and "I Wanna Go Home." A true island song with a colorful history that included versions from the Kingston Trio, Johnny Cash, Jimmie Rodgers and Arthur Lyman, Dick Dale's version was recorded four years before the version that shot into American consciousness, the Beach Boys' Kingston Trio–

influenced version. The Dale production is a string-heavy folk song and seems to have wandered in from somewhere else. If anything, it illustrates how surf music was always moving alongside other traditions. The rest of the vocal songs here include two doo-wop songs, allowing Dale to sing in his growling voice (Tony Allen's "Night Owl" and Dale's own "Peppermint Man") and the blues-rock "Fanny Mae."

The Cover

While most surf bands were content to wear the typical band uniform of the day (suit and tie), Dick Dale used his first cover to declare himself a king of surfing as well as surf guitar. Dale appears on a surfboard riding a wave with the name "Dick Dale and His Del-Tones" running along the bottom of the long wooden board.

The Ventures, Walk Don't Run (1960)

Ventures, *Walk Don't Run* (1960). *Dolton Records.*

Formed in Tacoma, Washington, the premier land-locked surf band released their debut album *Walk Don't Run* in 1960, recording all eleven tracks in the Seattle home studio of engineer Joe Boles. They had to hurry: the single "Walk Don't Run," a cover of a 1956 Chet Atkins instrumental, had reached no. 2 on the Billboard charts, and they needed an album to support. They went right back out on the road, leading to the strange replacement of the band with sunglass-wearing stand-ins on the cover.

"Walk Don't Run," the big-name single here, takes Chet Atkins's tune and keeps a similar tempo but uses a hard-picking guitar and drums sound to create the surf sound that Dick Dale created. The rest of the album is fantastic surf music, too. The Ventures show an enthusiasm for standards: R&B classic "Night Train" is very similar to earlier artists' versions without all the saxophone, while "Caravan" (which Arthur Lyman had performed in Exotica style) is reinterpreted as a springy surf tune. And their "Sleep Walk," while not as haunting as the

steel guitar–driven version recorded a year earlier by Santo & Johnny, is a fine rendition of the tune.

The Ventures would go on to become the providers of one of the most familiar surf tunes ever recorded: the *Hawaii Five-O* theme. The tune reached the no. 4 spot on the Billboard Hot 100 pop chart and would play in American living rooms throughout the show's twelve-year run from 1968 to 1980.

The Cover

The first thing to know about the guys tripping over their instruments on the cover of *Walk Don't Run* is *that ain't the Ventures*. The band was on tour at the time, and the studio created an album cover using four Liberty Records stockroom employees as stand-ins. Nevertheless, it's a delightful concoction, like something out of a Doris Day–Rock Hudson comedy: a model in a white blouse and high-waisted yellow pants is walking by, causing the Ventures to collapse in a heap. In this course of holding aloft in safety, the player in the foreground is giving star placement to a red-and-black Gibson 335, which was not the instrument of choice for the Ventures, who at this point played only Fender guitars.

The Sandals, the Original Soundtrack Music from Bruce Brown's
The Endless Summer (1964)

Unlike the beach party movies coming from American International and starring celebrities like Annette Funicello and Don Rickles, surf films were generally simple and often silent affairs. One surf film, however, transcended genre and became an international hit: Bruce Brown's 1964 documentary *The Endless Summer*, about a pair of surfers who travel the earth "chasing the sun." The film would gross $5 million domestically and $50 million worldwide. Brown had been making a surf film per year since 1962, but *Endless Summer* broke new ground with stunning photography and a soundtrack by the Sandals, whose surf songs alternate between Dick Dale–style pounding and hypnotic melodies that capture the glistening shimmer of the sun on waves.

Bruce Brown says that when he was approached by San Clemente band the Sandals, he expected "some kind of horrible Frankie Avalon thing,"

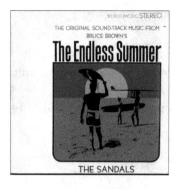

The Sandals, *The Original Soundtrack Music from Bruce Brown's The Endless Summer* (1964). *Liberty Records.*

but what he got was a moody surf collection that in turn dictated some of the tone of the film. The title theme, a languid, tremolo-led guitar tune, gives one the impression of walking the beach at sunset, all exercise thrown out the window. In tone and tempo it is the musical opposite of the Surfaris's "Wipe Out" or Dick Dale's "Misirlou." But the genius of the Sandals is that the theme is undeniably a surf tune. Dick Dale played doo-wop when he wanted to change the mood. The Sandals are giving us other sides of the surfer just as the movie shows surfers outside their natural element, traveling, clowning, schmoozing and, finally, surfing.

There's so much to like here! "Scrambler," which had been a single for the Sandals in 1964, is a fast surfer that makes use of a variety of percussion instruments, tambourine and guiro, plus motorcycle sounds and a walking bass. The motorcycles make a return in "TR-6." "Wild as the Sea" is another slow, haunting theme, making significant use of the reverb, tremolo, harmonica-like keyboard and the sound of the ocean. "Trailing," meanwhile, sounds more like a '50s rock-and-roll instrumental, a brief glimpse a decade into the past. "Good Greeves" makes use of a '60s-sounding pop organ sound.

In *The Endless Summer*, the Sandals have given us a surf record you can listen to anytime and completely lose yourself in the surf style. It is a complete tour of surf music—if you have a party in your Tiki bar and want to play one album, this is it.

The Cover

The cover to *The Endless Summer* soundtrack is one of the most recognizable surf album covers—indeed one of the most often seen surf posters—ever created. We see it on Mark Harmon's wall in *Summer School*, on the wall at the hospital in the Vietnam series *China Beach*, on the wall of a high school student on *Friday Night Lights.* It adorns T-shirts, mugs, mouse pads.

The tri-color negative image features surfers carrying their boards on a beach overlooking at a sea extending to the setting sun. Lili Anolik of *Vanity*

Fair suggested that the placement of the sun on the horizon adds to the allure: "Dawn or dusk? Early or late? Just after the beginning or coming up on the end?"

The image was created by twenty-two-year-old art student and art editor of *Surfer* magazine John Van Hamersveld and "captured the spirit not just of the movie but of the moment: the fun-in-the-sun, new-Garden-of-Eden innocence of early-60s Southern California."

Bruce Brown knew he had a hit with this image and insisted that it remain with the film from *Endless Summer*'s initial appearance to its wide, multinational release. The poster remains perhaps the epitome of surf images.

The Marketts, Out of Limits! (1964)

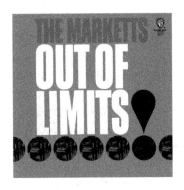

The Marketts, *Out of Limits!* (1964). *Warner Bros. Records.*

Kent Crowley called the Marketts a "decidedly non-surf group" of professional session musicians, including drummer Hal Blaine, who played on thousands of recordings, including forty no. 1 hit singles. Joe Saraceno, who also produced the Ventures, pushed the band toward surf because that was where the scene was. But the Marketts produced some great surf music.

The title track off the 1964 debut album *Out of Limits* was an ode to sci-fi television by band member Michael Z. Gordon. Originally called *The Outer Limits*, the album starts out with a riff on the theme from *The Twilight Zone*, close enough to the original that *Zone* creator Rod Serling and production company Screen Gems sued the band. The title was changed to *Out of Limits*. Still it's not an exact musical quote, and anyway the tune is a wild surf tune, with very '60s keyboards, wood percussion and a steady bass drum. It's a very creative piece that was instantly popular, selling over a million copies and going to no. 4 on the Billboard Hot 100.

The Marketts play a lot with a thriller and sci-fi theme through the album. The strangely named "Love 1985" sounds like a surf tune written by Henry Mancini with its *Experiment in Terror*-style organs. "Other Limits" is another *Twilight Zone* riff, and so is "Limits Beyond," presumably because once you've already been sued, why not keep going? "Borealis" is close

to honest-to-Tiki Exotica, with wind chimes and a soaring, whining keyboard. The finale, "Re-Entry," is a surf tune by way of TV westerns, a return to the earth. It really does sound like something from *Wild Wild West*. Clearly, even if they're pros from LA instead of teenagers barely out of their garage, the Marketts are having fun.

The Cover

The cover of *Out of Limits* is straight pop art, with the title and band name taking up most of the album. The only other design element is the series of tinted photographs of an old-fashioned folk dancing duo, which we can presume is intended as some kind of irony.

The Chantays, Pipeline (1963)

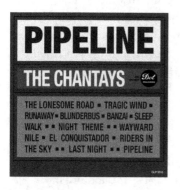

The Chantays, *Pipeline* (1963). *Dot Records.*

The Chantays were a band of teenagers from Santa Ana High School in Orange County who managed to bring a legitimacy previously unknown to surf due chiefly to one song, the title track to *Pipeline.* "Pipeline," named after a Hawaiian surf spot, is up there with "Misirlou" as one of the most recognizable surf tunes ever recorded, and it's been recorded a *lot* since the young California quintet wrote it. Bands as disparate as Lawrence Welk himself (in a very odd big-band–meets–surf cover), Dick Dale and Stevie Ray Vaughan together, Agent Orange, Pat Metheny and the Ventures have covered the tune. "Pipeline" showcases the Fender Reverb Unit with its "wet" sound in a pounding, hard-picked tune that captures the "surfing" feeling that Dick Dale sought to create. The song reached no. 4 on the Billboard charts, and the teens actually got to perform it (in swell collarless Nehru jackets) on *The Lawrence Welk Show* in 1963, the only surf band to do so. Competing with the guitars is an electric piano that shines in a solo at the middle. Crowley says the tune "stood alone as the only internationally charting song to represent what musicians and surfers meant when they referred to 'real' surf music."

This is a great surf album, including the favorite "Sleep Walk," slower than that recorded by the Ventures and more haunting, á la the Santo & Johnny original. Also interesting is "Banzai," another hard-driving tune á la "Misirlou," and "Riders in the Sky," a very "Pipeline"-esque cover of the old country ghost song.

The Cover

This 1963 album has a very simple four-color cover featuring only the band, album title and track list, looking almost as though it's been cut and laid out by hand. That's a decent look for a surf band—in the days of the Rendezvous Ballroom, they were often advertised on crude handbills.

MORE LISTENING

1. The Belairs, *Mr. Moto/Little Brown Jug* (1961)
2. The Astronauts, *Surfin' with the Astronauts* (1963)
3. Dick Dale, *King of the Surf Guitar* (1963)
4. Surfaris, *Wipe Out* (1963)
5. The Ventures, *Surfing* (1963)
6. Single: The Shadows, "Apache" (1960)

Tiki Film

Elvis Rules the South Pacific and Gidget Goes Everywhere

T iki Culture appears in countless films, but in this chapter we will explore films that most captured the backyard paradise that Tiki Culture sought.

THE ESCAPE: *GIDGET* AND *A SUMMER PLACE*

Frederick Kohner borrowed from his daughter's diaries (which presumably had been shared with him) to create the book *Gidget*, which in turn birthed the U.S. surf explosion. Tiki Culture is everywhere in 1959's *Gidget*. The distinctly Californian Gidget's travels in the films reflected the heady expansion of American power as she brought American and borrowed Hawaiian culture to distant states and different shores.

Originally, Gigdet appeared in a book called *Gidget: The Little Girl with Big Ideas*, published in 1957 by Frederick Kohner. Kohner had fled the Nazis with his family (including daughter Kathy) and become a Hollywood screenwriter. As Kohner observed Kathy's leisure time on the beach and the stories that she would tell him about surfing, he took notes and turned those into a novel. There were lots of changes between reality and fiction: real people like Terry "Tubesteak" Tracy became the Big Kahuna (originally spelled *Kahoona*.) And while Kathy really was called "Gidget" (short for the now politically incorrect "girl midget"), Kathy in

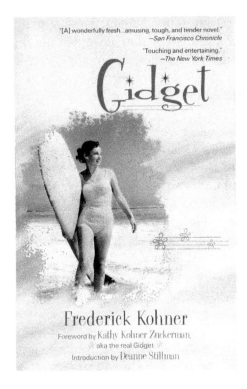

"[A] wonderfully fresh...amusing, tough, and tender novel."
—*San Francisco Chronicle*

"Touching and entertaining."
—*The New York Times*

Gidget

Frederick Kohner

Foreword by Kathy Kohner Zuckerman
aka the real Gidget

Introduction by Deanne Stillman

No single book did more to launch the national obsession with surfing than Frederick Kohner's 1957 *Gidget*, about a diminutive girl who yearns to join the newly forming surf culture. She falls under the sway of the Big Kahuna, a damaged vet hiding from responsibility in a tiny grass hut. *Penguin Random House LLC.*

media became Frances or "Francie," with no last name. Gone also, or at least unmentioned, was Gidget's Jewish heritage. Although in later books Gidget's last name would be given as Hofer, her film and TV surname would be the much more gentile-sounding "Lawrence."

Kohner's book is steeped in an idea of escape from American culture. Gidget, our first-person narrator, is a diminutive girl who complains of not being as curvy as her friends. When she goes to the beach (Malibu), she isn't particularly interested in attracting the lunkheads that her friends like. Instead she falls into the orbit of a likable boy named Jeff, nicknamed "Moondoggy," and his surfing guru Kahuna, the living essence of Tiki escapism.

The Big Kahuna lives in a hut on the beach, from which he directs surfing activities among his gang, holds court and bestows special nicknames on all of the other surfers. Where the other surfers are teens and college-aged young people, Kahuna is thirty or older. He hosts popular luaus, wears ragged clothes and a straw hat and collects island artifacts such as masks.

Kahuna defines the culture for the veritable surfing cult that Gidget joins—a culture of dropping out and doing no work. And Moondoggy, a young person who should be going to college (and who is seen returning

to college at the end of the film), is convinced that Kahuna has found the secret to happiness. Gidget is in love with both of these men, but mostly she is in awe of Kahuna and in love with Moondoggy. While the film resolves the two men's storylines by having them return to a world of responsibility, the book remains focused on Gidget and her satisfaction with the sport of surfing.

This book was the first national exposure to the sport of surfing, which originated in Hawaii. (Kahuna calls it the "sport of Kings.") Surfing had been nearly wiped out on the way to Hawaii's modern existence. When missionaries encountered it, they found surfing to be disturbingly sensual, as the surfers were always nearly or completely naked.

But in the twentieth century, surfing made a return, and by the 1950s, it had come to California. Kathy Kohner's Malibu beach was still a relatively uncrowded spot for enthusiasts of an obscure, athletically demanding sport. The popularity of Frederick Kohner's book played a great part in driving awareness of surfing beyond the beach.

In *Gidget*, Kahuna is our guide to the culture of dropping out and living hand-to-mouth in pursuit of pleasure. In the film, Kahuna's retreat from a violent world is made more explicit: he wants to get away from his memories of "that Korea jazz." Kahuna's retreat from the horrors of war echoes that of author Kohner, who fled Germany and World War II to join the opulent film industry. Gidget however stands for a different generation, the immigrant too young to remember the old country, who seeks to drop out of the pressures of teen-hood in an industrial and expanding country. This idea of escape, borne of Kohner and demonstrated by the age-divergent characters Gidget and Kahuna, contributed to the enormous popularity of the book. To join Kahuna's beach is to trade in the pressures of the establishment for an idyllic existence that asks little of the escapee. Kohner's *Gidget* was a bestseller that very quickly became a film. The 1959 film *Gidget* features James Darren as Moondoggy and Sandra Dee as the title character. Cliff Robertson is the perfect Kahuna, played as a man that absolutely should have better things to do but isn't doing them.

It is impossible to watch the film and not imagine World War II and Korean War veterans in the audience watching this film and wishing that they could do what Kahuna has done: set aside responsibilities, live next to the sea, eat whatever he can catch and spend all day at leisure.

The movie is rife with Tiki imagery, straw hats and torches and various night-lit lounges.

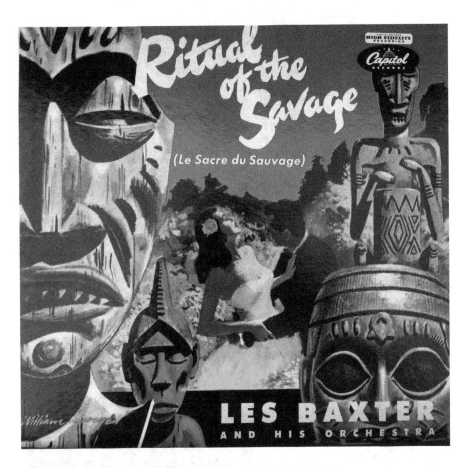

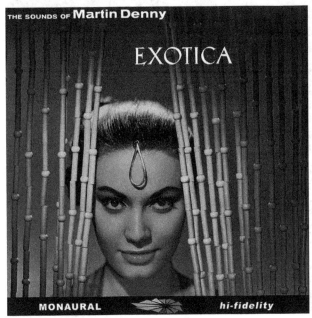

Above: Les Baxter, *Le Sacre Du Sauvage* (1951). *Capitol Records*.

Left: Martin Denny, *Exotica* (1957). *Liberty Records*.

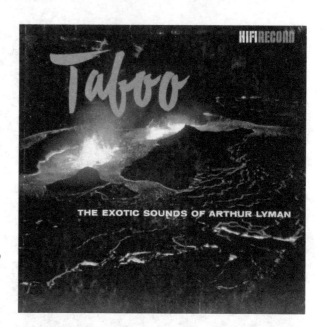

Right: Arthur Lyman, *Taboo*
(1958). *HiFi Records.*

Below: Dick Dale, *Surfers'
Choice* (1962). *Deltone Records.*

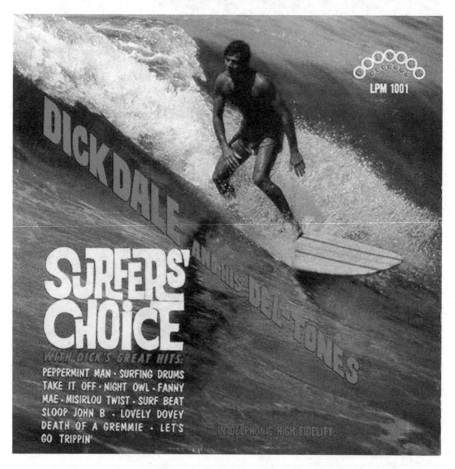

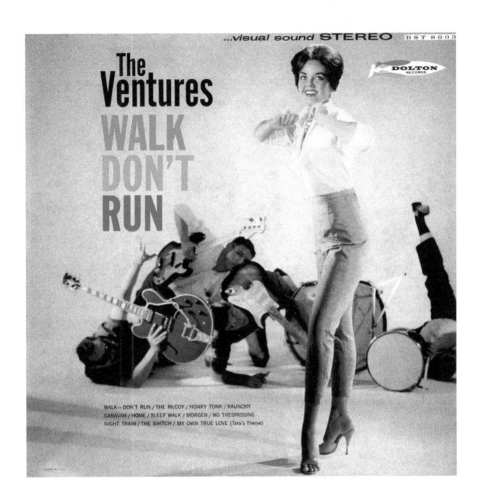

Above: Ventures, *Walk Don't Run* (1960). *Dolton Records.*

Left: Cliff Robertson, Sandra Dee and James Darren in a film that pits budding sexuality against Korean War–era PTSD: 1959's *Gidget*. *Columbia Pictures.*

Paradise, Hawaiian Style (1966) shows off the many resort hotels of Hawaii, including several of the stomping grounds explored by Gidget when she went Hawaiian. *Paramount Pictures.*

The 1963 comedy *Donovan's Reef* explores the tenuous relationship between veterans of the war and the native peoples of the South Pacific and features a surprisingly clear-eyed look at the racism that the characters both hold and try to overcome. *Paramount Pictures.*

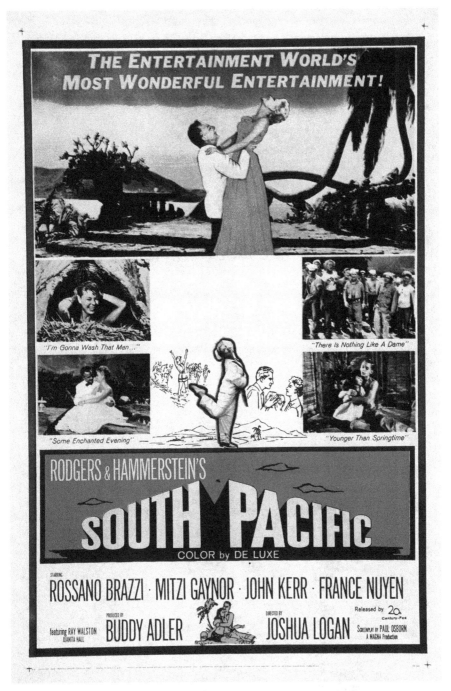

A key piece of the founding of Tiki culture, *South Pacific* balanced the horrors of the Pacific theater with the romance and bored hijinks of the men stationed on Pacific Islands. *20th Century Fox, 1958.*

Gilligan's Island (1964–67) featured an ensemble cast, each representing a basic human vice (lust, naivety, gluttony and so forth) in an idyllic island setting they could never escape. *Warner Bros.*

In *The Man in the Gray Flannel Suit* (1956), Gregory Peck strives to succeed in the expanding American economy while dealing with the guilt and horrors of his experiences in World War II. *20ᵗʰ Century Fox.*

Bob Hope plays a culture writer exploring the suburbs as though they were a newly discovered planet in *Bachelor in Paradise*. He makes a Tiki dojo of sorts out of his backyard and gives the "natives" of suburbia lessons in romance. *MGM*.

Above: Don the Beachcomber displays a collection of Tiki mugs. *Jason Henderson.*

Left: Proprietress of the Royal Hawaiian in Laguna Beach and ambassador of Tiki chic Hasty Honarkar. *Jason Henderson.*

The Royal Hawaiian's classy, bamboo-lined interior. *Jason Henderson.*

One of the animated dioramas of Trader Sam's. *Jason Henderson.*

Tiki mainstay, the Mai Tai. *Wikimedia.*

The coconutty Blue Hawaiian. *Yuanbin Du.*

Above: Troy Donahue and Sandra Dee find love in a tamed seaside jungle in *A Summer Place* (1959). *Warner Bros. Pictures.*

Below: In *Beach Party* (1963), Robert Cummings dons an aloha shirt to blend in on the "primitive" beach. *MGM.*

Above: Lee Marvin presides over a Tiki bar in *Donovan's Reef* (1963). *Paramount Pictures.*

Left: Mitzi Gaynor as the lost-in-love Nurse Nellie in 1958's film version of *South Pacific*. *20th Century Fox.*

Elvis with one of his many girlfriends doing a number in a Tiki bar in *Paradise, Hawaiian Style* (1966). *Paramount Pictures.*

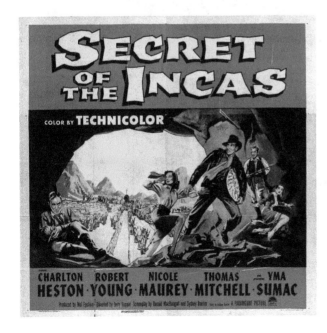

Yma Sumac provided the Exotica music for a proto–Indiana Jones adventure starring Charlton Heston in 1950's *Secret of the Incas,* one of many films to play up the lure of the exotic. *Paramount Pictures.*

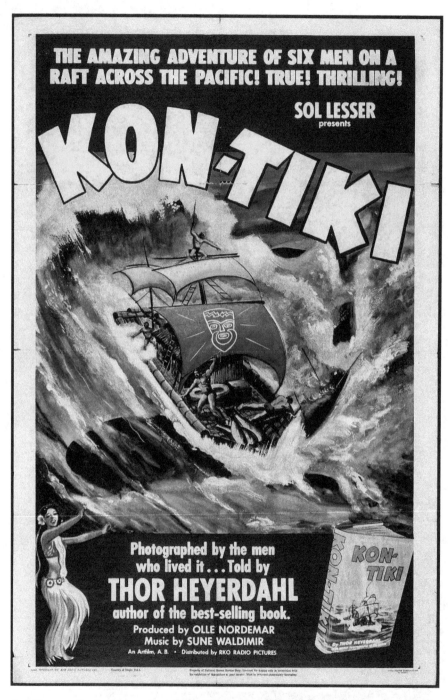

A vivid poster for the film version of Thor Heyerdahl's seminal Pacific journey, *Kon-Tiki*. *Thor Heyerdahl, 1950.*

The menu of LA's Don the Beachcomber, the bar that played a vital role in the creation of Tiki Culture. *Wikimedia.*

Wooden masks displaying Tiki motifs (pineapple, palm tree, orchid). Masks continue to be a popular collectible among Tiki enthusiasts. *Julia Guzman.*

The mainstay of any backyard paradise: the Tiki torch. *Kevin Finneran.*

Surf music, the pounding sound preferred and originated by surfers, dominates Tiki today. *frank mckenna.*

Sixteen-year-old, five-foot, four-inch Sandra Dee makes a nearly perfect (although very blond) Gidget, excitable and wide-eyed and constantly challenging the men who try to push her around. Gidget is portrayed as only newly and vaguely aware of the sexual power that she exerts over the men around her. Her presence moves Moondoggy to want to become an adult and go back to college and inspires Cliff Robertson's Kahuna to be a better man and return to his middle-class lifestyle.

Kathy Kohner remembers,

> *I came upon the surfers who dwelled beside Malibu Pier....It was a most alluring lifestyle....They were boys who lived on the beach (literally in a shack on the sand)....They all had nicknames....I was amused and fascinated with these handsome young surfers and their love and pure devotion to riding the waves at Malibu. It seemed as if there wasn't any other aspect to their lives except taking in the sun and sea, waxing down their boards, and paddling out looking for a great wave to catch. This was their life—nothing else.*

The surfer gang in 1959's *Gidget* hang out around the Big Kahuna's Tiki hut, a formidable fortress for Gidget to penetrate. *Columbia Pictures.*

Left: *Gidget Goes Hawaiian*, 1961. *Columbia Pictures*.

Right: In *Gidget Goes Hawaiian* (1961), the surf queen goes to Hawaii and shows off the Hawaiian Village Hotel, a leading home of Exotica music. *Columbia Pictures*.

The box-office success of *Gidget* led to two theatrical sequels, one in 1961 and one in 1963. In 1961's *Gidget Goes Hawaiian*, Gidget follows her sport of choice back to its birthplace just at the moment when the new fiftieth state had become a major pop cultural interest to Americans.

James Darren returns as Moondoggy, but the adult dropout character Kahuna does not appear. Nor does Sandra Dee—Deborah Walley (the only film Gidget who could actually surf) steps in as Gidget.

Overall, *Gidget Goes Hawaiian* itself has almost none of the themes of the original film. It's not particularly about escape or responsibility or any of those questions that the first movie managed to raise on top of the original's fairly simple romance plot. *Gidget Goes Hawaiian* is more of a sitcom involving a lot of misunderstandings about whether Gidget's parents are growing unhappy with each other against the backdrop of the famous Royal Hawaiian Hotel. Still, we get a lot of wonderful Tiki imagery as the characters spend so much time lounging about at night listening to bands and engaging in banter.

The third film, *Gidget Goes to Rome*, gets even farther away from the original themes of 1959's *Gidget*. This time, Gidget (now played by Cindy Carol, the third Gidget in as many movies) travels to Rome in the company of a nosy aunt and promptly begins chasing an Italian boy named Paolo to test Moondoggy, once again played by James Darren. This is much less a summer or Tiki movie and more a travelogue film á la 1954's *Three Coins in the Fountain*.

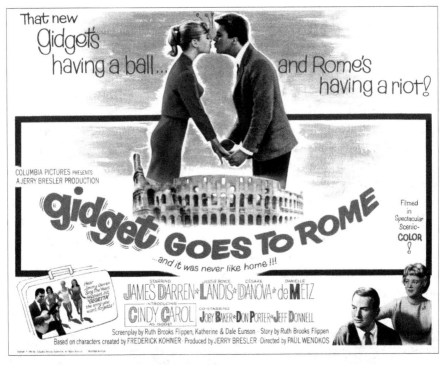

Above: Gidget Goes to Rome, 1963.
Columbia Pictures.

Left: *A Summer Place* (1959) was all about
unquenched desire, played out amidst a
crumbling beach resort. *Warner Bros.*

The Gidget phenomenon would continue for decades on the small screen. The 1965–66 TV series *Gidget* expanded the 1959 film into one season of teen shenanigans starring Sally Field. After a pair of TV films about the character that veered far from the surf culture origins of the first book (1969's *Gidget Grows Up* and the 1972 *Gidget Gets Married*), Gidget was reimagined as a thirty-something travel agent still intent on spending as much time as possible on the beach in the 1985 *Gidget's Summer Reunion*. This version of the character spun into a two-season revival series, *The New Gidget*, starring dark-haired, five-foot, two-inch Caryn Richman. More than any other actress, Richman's spritely Gidget really does seem like a screen version of Kathy "Gidget" Kohner.

In film, the real companion to the fraught and sometimes-melancholy 1958 *Gidget* is not its own wayward sequels but *A Summer Place*, released in 1959 just seven months after *Gidget*. Starring Richard Egan, *Gidget*'s Dee and Troy Donahue, *A Summer Place* explores nearly every conceivable soap opera topic: teen lust, alcoholism, class, infidelity, unwanted pregnancy, child abuse, domestic violence, voyeurism—a lot goes on at this shabby inn off

Troy Donahue and Sandra Dee in *A Summer Place* (1959). *Warner Bros.*

the coast of Maine. *A Summer Place*, based on a novel by Sloan Wilson (who also wrote *The Man in the Gray Flannel Suit*), features two families in conflict as two love stories play out. In one storyline, former teen loves Ken and Sylvia (Richard Egan and Dorothy McGuire) rekindle their beach romance decades after leaving each other for joyless marriages. Meanwhile, athletic teen Johnny (a young, bronze Troy Donahue) and Molly (virginal, still-sixteenish Sandra Dee) defy their parents' warnings to run away together after their own romance amid rocks and crashing waves.

This is pure soap opera stuff, played out on beaches and under Tiki torches. Like *Gidget*, *A Summer Place* featured a multi-generational cast and could appeal to the adults in the audience, the men in the gray flannel suits and their own long-suffering spouses. Like the best of Tiki Culture, these films lead the viewer to ask, "Is there a summer place for me?"

In the wake of these two movies, Sandra Dee would become a major star, and movies taking place on the beach would move away from adult-neurosis themes toward plots that focused on the younger generations on screen.

In California, *Gidget* caused trouble for surf enthusiasts. The beaches were already growing crowded after the success of Frederick Kohner's original novel. The film made the problem worse, launching an entirely new genre: the beach movie. As with the Gidget movies, the beach party films began largely concerned with the conflicts and romances of adults—but they never stayed that way.

ENDLESS SHORELINE: BEACH PARTY MOVIES

Beach Party, released in 1963, starred Robert Cummings as an anthropologist who has come to the beach to study the mating habits of young people. This is the first film to introduce Frankie and DeeDee, the young prince and princess of the Southern California sand, as they hold court in a seemingly endless summer. The pair are played by popular musician Frankie Avalon and Annette Funicello, then known as the gorgeous young star of *The Mickey Mouse Club*. Frankie and Annette would command a series of eight films released over a remarkably short period from 1963 to 1966. Considering that the *Gidget* films took two years each to release, these movies would hurry back, repeating the same themes again and again. But in the original *Beach Party*, Frankie and Annette are barely lead characters and only factor into the plot as they relate to lead adult Robert Cummings.

 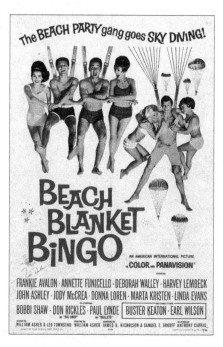

Left: 1963's *Beach Party* was the first of the beach party movies, and the poster features Frankie Avalon and Annette Funicello. But the plot was aimed squarely at adults, as Robert Cummings tries to prove that beach culture is a recreation of "primitive" ritual. *MGM*.

Right: Beach Blanket Bingo (1964). *MGM*.

In *Beach Party*, Cummings plays a renowned anthropologist accompanied by a long-suffering assistant who is desperately in love with him and, as these things go, is unable to get him to see it. Trouble ensues when Annette begins showing Cummings around in order to try to make Frankie jealous.

Cummings's appearance is what grounds the *Beach Party* series in Tiki Culture—explicitly, Cummings has arrived in an effort to prove that American youth culture is a thinly masked recreation of "primitive" culture with its rhythmic dancing and mating rituals. (The same connection is drawn by *The Great Gildersleeve*'s Willard Waterman in 1964's *Get Yourself a College Girl*.) But what Cummings proves to us is that adult men yearn for a more primitive life and time, away from the structures of the professions. He acts out for the adult audience the fantasy of ditching one's suit for Bermuda shorts and a straw hat. *The Dick Van Dyke Show*'s Maury Amsterdam appears (in a wild goatee) as a sort of alter ego of Cummings, an aging man ruling over a coffee house where young, beautiful surfers hang out and recite beat

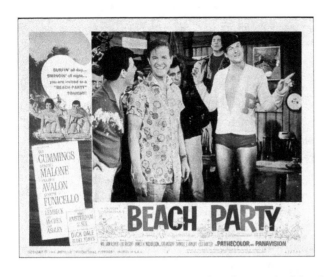

Anthropologist Bob Cummings may wear the aloha shirt, but he finds himself out of place amidst the kids of *Beach Party* (1963). *MGM.*

poetry. Dick Dale himself provides the musical backdrop for Cummings's and Amsterdam's (and our) escape.

While *Beach Party* is a romantic comedy about middle-aged Robert Cummings finding himself (and an age-appropriate girl), the beach party movies would go in a whole new direction after that. When it came out, *Beach Party* performed well at the box office, beating out former Gidget Sandra Dee's *Tammy and the Doctor.* So producer Samuel Arkoff of American International Pictures started churning out the *Beach Party* series, returning Frankie and Annette (and various others, in various combinations) with *Muscle Beach Party* (1964), *Bikini Beach* (1964), *Pajama Party* (1964) and *Beach Blanket Bingo* (1965). At that point, five movies and a mere year and a half into the series, the films began to branch out into other milieus with non-surf *Ski Party* (1965); another surf film, *How to Stuff A Wild Bikini* (1965); military parody *Sgt. Deadhead* (1965); spy spoof *Dr. Goldfoot and the Bikini Machine* (1965); and horror spoof *The Ghost in the Invisible Bikini* (1966). The series would conclude with two car culture films, *Fireball 500* (1966) and *Thunder Alley* (1967).

Most of these films were generally dedicated to showing teens involved in light comedic plots of jealousy, mild trickery, oblique (never graphic) references to sexuality, the desire on the part of girls to maintain virginity and the question of what to do with one's life. Put together, they inhabit one long, endless summer. The *Beach Party* movies ruled film for a little less than four years and then disappeared.

ELVIS GOES HAWAIIAN: *BLUE HAWAII*, *GIRLS! GIRLS! GIRLS!* AND *PARADISE, HAWAIIAN STYLE*

The exact same year that Gidget went Hawaiian, Elvis Presley became that new state's foremost media spokesperson. Hawaii became a state in 1958, and its influence on American culture showed itself in the growth of fascination with Polynesian drinks and various Tiki elements. Originally from Memphis, Tennessee, Presley invested in businesses, restaurants and hotels in Hawaii and took an interest in showing off the state in film. The results were *Blue Hawaii* (1961), *Girls! Girls! Girls!* (1962) and *Paradise, Hawaiian Style* (1966). In many ways, the Elvis Hawaii movies capture the postwar themes of Tiki Culture even more than the *Gidget* and *Beach Party* movies. A key reason is that Elvis, though only five years older than Frankie Avalon, always appears on film as a free-living adult, whereas Frankie appears as someone trapped between high school and college.

In *Blue Hawaii*, Elvis is a wealthy young man who has returned from the army to Hawaii, where his parents (Angela Lansbury and Roland Winters) own a pineapple plantation, and must decide what he will do with his life. It's a tough call: Elvis wants to surf and hang out with his local, ethnically Hawaiian friends, singing and carousing on the beach. He reignites his love affair with Maile Duvall, a Hawaiian girl played by Joan Blackman (though Joan is nobody's idea of a native Hawaiian). Elvis clashes with his parents' privileged lifestyle and takes a job as a tour guide, working with his girlfriend and dealing with the romantic attentions of beautiful visitors who come to Hawaii.

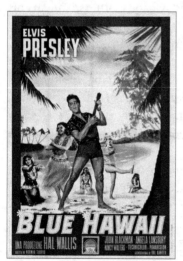

Blue Hawaii (1961). *Paramount Pictures.*

This plot, in which Elvis mainly drives around pointing out the various beautiful settings of the state of Hawaii, gives the film an opportunity to show us precisely the same sights. Everybody in the film depends on the patronage of visitors from the continental United States, whether for business or pleasure.

In the end, Elvis chooses to form his own touring company, merging the business acumen that is his inheritance with his own appreciation for native culture. *Blue Hawaii* showcases the fiftieth state in a gorgeous

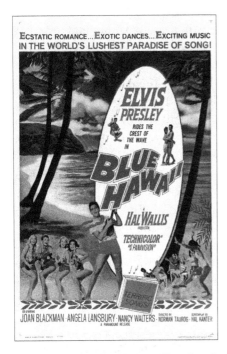
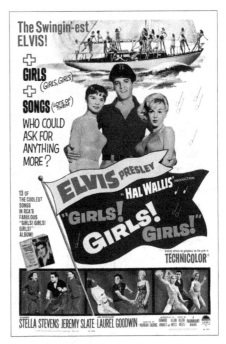

Left: The first of Elvis Presley's Hawaii cycle, *Blue Hawaii* (1961), was about the return of a GI to an island paradise. Elvis was in love with the new state and determined to show its wonders to Americans. *Paramount Pictures.*

Right: 1962's *Girls! Girls! Girls!*, the second Elvis Hawaii movie, featured Elvis as a boat captain and Tiki bar singer. *Paramount Pictures.*

way while only barely making mention of the tensions between the white upper class and the inheritors of the culture of Hawaii, who don't benefit economically from the exploitation of this new jewel. Still, it's remarkable that the tension is there at all.

The film heavily features the Hilton Hawaiian Village, which would be the hotel occupied by Troy Donahue in the television show *Hawaiian Eye* and out of which lead Anthony Eisley would run his detective agency. *Blue Hawaii* was the tenth-highest grossing movie of 1961, earning $5 million and begging a sequel.

Elvis met this demand the following year with *Girls! Girls! Girls!* (1962), which opened at number six and received a Golden Globe nomination for musical comedy. In this one, Elvis is no longer a rich young man but instead is an ethnically Hawaiian fisherman who desperately wants to buy the boat that he has been working on. This time, the plot involves much more

economic anxiety, as we see Elvis grapple with a snotty young man who has bought the boat out from under him after Elvis was led to believe he could purchase it for himself.

Elvis moves back and forth between the Tiki-themed nightclub where he sings and earns extra money by night and ferrying recently arrived patrons who want to fish Hawaiian waters by day. But by spending so much time looking away from the water toward the nightclubs, this film is less a travelogue than *Blue Hawaii*.

It would take one more try for the Elvis/Hawaii formula to be successfully reproduced.

Although *Blue Hawaii* is the best-remembered of Elvis's Hawaii films, to this writer's eye, the third and last is a more beautiful film and has a more interesting plot.

Paradise, Hawaiian Style (1966) features Elvis as an airline pilot recently tossed out for vaguely defined misbehavior. In much the same way that

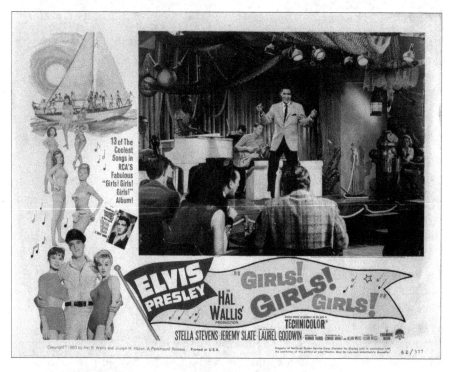

In Elvis's second Hawaiian movie, *Girls! Girls! Girls!* (1962), he moonlights as a singer in a gorgeous Tiki bar. Note the hanging lamps and nets, common Tiki motifs. *Paramount Pictures.*

Kahuna in *Gidget* has given up commercial flying and fled to paradise, Elvis has returned to his Hawaiian home. Elvis, however, doesn't intend to give up flying altogether—he turns a local taxi helicopter service into a successful venture by taking advantage of the knowledge and goodwill of various girls who work at the major resort hotels in Hawaii.

Paradise, Hawaiian Style provides unmatchable views of Hawaii and a lot of action around palm trees and the beach. The film came out in 1966, the last year of the major surf party movies, and it is still very much a part of this initial burst of beach-obsessed films. From 1958 to 1966, the point of films such as *Paradise, Hawaiian Style* and *Beach Blanket Bingo* was to spend time around beautiful surroundings. This period roughly coincides with the surf music explosion and the end of the Exotica movement in music.

For those with a much more adult eye for plot, three major films capture Tiki Culture with more mature themes.

TALES OF ADULT PARADISE:
SOUTH PACIFIC, DONOVAN'S REEF, BACHELOR IN PARADISE

The musical *South Pacific* is often cited as kicking off the fascination with Polynesia and Tiki Culture in general. *South Pacific* was based on James Michener's *Tales of the South Pacific*, a collection of stories about his time in the U.S. Navy during the Pacific war.

Fortunately for most of those involved, the majority of Michener's time on the island did not involve much fighting, and the movie gives us a strange island paradise in which sailors and GIs wait for action to happen and kill time flirting with nurses and locals. The musical, based on the Broadway show adapted from Michener's book, stars Mitzi Gaynor as Nellie Forbush, a nurse who has fallen in love with Emil (Rossano Brazzi), a French expatriate living on the island. Danger comes when Brazzi is recruited by the Americans to join a dangerous undercover mission.

But the chief themes of the film are about whether Nellie can find love in a faraway land and whether she can accept the fact that the man she has fallen in love with has children who are not "white."

The same theme appears again in *Donovan's Reef* (1966), in which a wealthy young lady named Amelia Dedham (Elizabeth Allen) visits the island of Haleakaloha, French Polynesia, where her father (a doctor whom she has never met) has lived for many years. Her father has become a

Right: Bob Hope tries to romance the icy Lana Turner in *Bachelor in Paradise* (1959). To seal the deal, he takes her to a swingin' Tiki bar. *MGM.*

Below: Charlton Heston has to hide his love for a native Hawaiian girl in the soapy *Diamond Head* (1963). *Columbia Pictures.*

beloved caretaker and provider of medical services and is a close friend of John Wayne, another expatriate who runs a bar called Donovan's Reef on the island.

The plot heavily revolves around Amelia's growing love for John Wayne and her distaste for what she thinks are John Wayne's children, who like those of Nellie's lover are half white.

In fact, John Wayne is pretending that these children are his because they are the children of Jack Warden, Amelia's father, and Wayne would spare her this shock. This whole plot is played matter-of-factly, the racism of white society a given that the characters have to deal with from day to day.

In both *South Pacific* and *Donovan's Reef* (as well as the melodrama *Diamond Head* of the same era), there is a tension between the love of the "exotic" and of the pleasures of an island paradise. In both, characters experience love and familial relationships across the races, yet deal with their own racism as well as that of those around them.

Another excellent adult Tiki film is *Bachelor in Paradise*, a 1961 comedy starring Bob Hope. *Bachelor in Paradise* features Hope returning to Los Angeles to deal with an IRS problem that results from his accountant running away with all of his money while he was overseas. Bob Hope decides that the only way that he can regain his riches is to write a new travel book that will describe life in modern America, and so he rents a home in what he regards as one of those new-fangled suburbs.

The film gives us a tour of the suburb as though we have never seen one before. Hope falls in love with Lana Turner, his real estate agent and landlord, and begins to tutor all the local housewives on how to create an exciting life. (It is understood right away that the safe environment of the suburbs dulls the passions.) Several times, we get to see the Tikiesque backyard paradise that Hope builds, where he gives the women lessons in sexiness and deportment.

Bachelor in Paradise is an amazing movie to see today, because it gives us a look at our lives from the perspective of somebody who is not familiar with them at all.

Starting in 1958 and moving roughly to the second half of the 1960s, popular films showed Americans a type of escape that came with palm tree shade and Tiki torches among the anxiety of what it meant to be an American in a time of remarkable growth and ever-more-demanding work.

Tiki TV

The Intimacy of Escape

S ince the 1930s, movie theaters were the transcendent houses of secular worship for Americans—a place where the moviegoer would be transported and see himself or herself "bigger than life." Tiki-themed or not, movies always have a sense of the grandiose, so that even dullness can look somehow exciting. The shabby little house that Gregory Peck inhabits in *The Man in the Gray Flannel Suit* becomes *magically* shabby. Putting something on the big screen renders it aspirational merely by virtue of its size and the fact that we're devoting time to looking at *this* image and not others on a silver wall bigger than our own homes.

Television is entirely different—where the movies render the ignoble grand, TV makes the grand intimate. The small screen in the living room in the 1950s became a sort of beloved porthole, always in the corner ready to entertain. The people on the screen are intimately familiar to us, like family members, and it's no surprise that the most beloved programs tended to be about families. Viewers followed Robert Young from the radio to the television with *Father Knows Best*, living their own lives alongside the lives of the Anderson family.

Aside from then-popular anthology programs like *Playhouse 90* and *The Twilight Zone*, even non-family programming still featured ersatz families in their recurring casts. The viewer watches Ed McBain's *87th Precinct* or *77 Sunset Strip* and every week sees familiar stalwart lieutenants, curious detectives, flirtatious secretaries and shifty informants. This viewer escapes from the family that likely surrounds him or her and, perhaps

Connie Stevens was Cricket, the singer and sometime detective of the popular Tiki-themed TV series *Hawaiian Eye. Warner Bros.*

unconsciously, joins another family, finding home somewhere else.

In the day of *The Man in the Gray Flannel Suit*, the growing demands of the expanding economy made the safety-valve of the living room ever more necessary. The man couldn't escape, after all, not without condemning his loved ones to misery and himself to disgrace. So television grew and grew.

Television shows that were heavily tinged with Tiki Culture—Sven Kirsten and others call it "Tiki TV"—made the escape more overt. The viewer still met a recurring cast, a replacement family, but on these shows, the family itself had escaped the industrial life and found itself among palm trees and surf.

A whole slew of TV programs featured men literally disappearing from their stateside lives and reinventing themselves as South Sea adventurers. *Captain David Grief*, a thirty-nine-episode 1957 syndicated show based on Jack London's writings and shot on location in Mexico, featured an American making his life as a South Seas trader. Another thirty-nine-episode series from 1962, *The Beachcomber*, from Incorporated Television Company, told the story of an executive very like the men in gray flannel who drops out and wanders an island in the South Pacific. *Follow the Sun*, a thirty-episode ABC program from 1960, featured freelance journalists solving mysteries in (a Burbank version of) Honolulu. Gardner McKay starred for ninety-one episodes from 1959 to 1962 as the captain of the schooner *Tiki III*, tooling around the South Pacific and also solving a lot of mysteries.

Wandering, always wandering. What these shows have in common is that the main characters are never tied to a desk. Detectives live like hobos with money, never scrounging, living simply but with plenty of alcohol and good humor. Journalists live like detectives. All lead lives of carefully designed leisure; they love to hate their work and spend all their time on it, flowing from one locale to the next.

Perhaps the most important Tiki TV show is the four-season ABC series *Hawaiian Eye*. Running from October 1959 to April 1963, the show began each week with the image of a Tiki idol on the beach, with a theme by Jerry Livingston and Mack David that was impossible to get out of your head:

Left: Anthony Eisley played Tray Steele, founder of the Hawaiian Eye detective agency, located in the tony Hawaiian Village Hotel in Honolulu. *Warner Bros.*

Right: Probably the first Tiki idol seen by Americans across the country, the logo of *Hawaiian Eye* (1959–63) filled the screen before each commercial break. *Warner Bros.*

Hawaiian Eye! Hawaiian Eye!
The soft island breeze brings you strange melodies and they tell of
Exotic mysteries under the tropical spell of
Hawaiian Eye!
Where love and adventure await
This is your fate—and you can not stray from, You can't run away from
Hawaiian Eye!

Sven Kirsten said that "the effect of the logo Tiki for Hawaiian Eye series appearing in every living room cannot be underestimated." The Tiki idol acted as a talisman while the repetitive theme played—the viewer was being chanted into an alternate world.

Alternating with images of the *Hawaiian Eye* Tiki idol appeared the stars, which through the four-season run consisted of two or three handsome men and at least one beautiful woman, usually Connie Stevens.

The show was part of an experiment in world-building by Warner Bros. and ABC, which created several shows about detective agencies in "exotic" locales. *77 Sunset Strip*, lasting six seasons, took place in LA; *Bourbon Street Beat* (one season) in New Orleans; and *Surfside 6*, two seasons ("in Miami Beach!"). Next to the original *77*, *Hawaiian Eye* performed best. As with the others, the

Troy Donahue, star of *A Summer Place*, solved crimes and juggled women weekly on *Hawaiian Eye*. *Warner Bros.*

bulk of the show was shot in Burbank, with the characters returning yearly for B-roll and location shooting in Hawaii.

The show involved Anthony Eisley as detective Tracy Steele and Robert Conrad as his partner, half-Hawaiian (like musician Arthur Lyman) Tom Lopaka, who run the Hawaiian Eye detective agency from the complex around the Hawaiian Village Hotel (later the Hilton Hawaiian Village Hotel). They were aided in their adventures by Connie Stevens as Cricket Blake, a photographer and singer at the world-famous Shell Bar, and singer Poncie Ponce as Kim, a taxi driver with connections all over the island.

When Anthony Eisley left the show after the third season, Troy Donahue (fresh from the "exotic locale" detective show *Surfside 6*) joined the show as Philip Barton, a "hotel social director" who nevertheless functioned as (what else?) a detective. Troy Donahue had grown up in Tiki surroundings before our eyes, having starred in *A Summer Place* in 1959, in which American miseries were made glamorous by pounding surf up and down the East Coast.

Even as the main characters maneuver through the lives of guest stars caught up in misery and murder, the tone of the show remained light. Amid humorous music cues and rapid, wry dialogue, alcoholic recluses finally emerged from their shells, angry vets let go of lingering guilt, jealous husbands made peace with the collapse of marriages. Everyone was amused, but danger lurked everywhere. Whereas the real Honolulu had a murder rate of about one per month, the Honolulu of *Hawaiian Eye* saw at least one murder a week, counting only the ones involving the detectives we know. Every episode involved at least one song, as the characters tended to end every adventure nursing wounds and recapping plot threads while sipping Mai Tais at the Shell Bar while Cricket sang.

Arthur Lyman appeared on the show ten times, playing and accompanying Stevens's Cricket. The fantasy here came full circle, with Lyman playing Exotica music—a new genre intended to suggest exotic locales rather than any real place—in an imitation version of the real club in Honolulu where he could regularly be found.

When asked about the relentlessly pleasant tone of *Hawaiian Eye*, Anthony Eisley said, "I too would like to see more food for thought on television. I have children whose viewpoints will be largely affected in certain areas by their many hours gazing at the one-eyed monster. But our world is solemn enough as it is. I'd hate to limit them—or myself—to a leisure-time diet devoid of laughter, adventure and romance." That's Tiki as concisely explained as possible.

Whereas *Hawaiian Eye* was a cocktail-hour kind of show full of elegant bonhomie amid torches and palm trees, the other persistent Tiki TV show went full-bore in the direction of farce and slapstick. Sherwood Schwartz's *Gilligan's Island*, running from 1964 to 1967, told the story of seven American souls shipwrecked about three hundred miles from Honolulu. Two were retired navy men now running the small charter cruise vessel on which the "castaways" meet their fate: Alan Hale Jr. as the Skipper and former teacher Bob Denver as the rubber-bodied First Mate Gilligan. The rest were walking representatives of American moral and class anxiety: the industrious and handsome space-age Professor (Russell Johnson), the family- and farm-loving Mary Anne (Dawn Wells), the dangerously sex-positive "Movie Star" Ginger (Tina Louise) and a King and Queen of Old Money, the Howells (Jim Backus and Natalie Shafer).

The world of Gilligan's Island was a strange and magical one. For three seasons, once shipwrecked, the castaways were unable to escape to civilization. Instead, they rebuilt it in a Tiki image. Between the handiness of all concerned and the brilliance of the Professor, the castaways built a whole village of bamboo and palm fronds. They cleared sections of forest and set up night watches. They fashioned hammocks, clothing, pedal-powered sewing machines, roulette wheels, clocks, washing machines and, at one point, jet fuel from the raw materials available on the island.

To anyone watching the show—and that seems to include everyone—the idea that these geniuses could not escape an island on which they already had a boat (with a two-foot hole in its side) was so absurd that to ask about it was to destroy the series. The case was simply that the castaways were trapped.

Every week, some opportunity to escape would appear. A spy would wash ashore. A plane would appear overhead. Gilligan's teeth would become a radio. All concerned would attempt to exploit the newfound opportunity to escape. And yet each time, the attempt would end in failure, usually through the bumbling of Gilligan, who would trip over and destroy the castaways' palm-frond HELP sign, drop the radio in the ocean or frighten away the

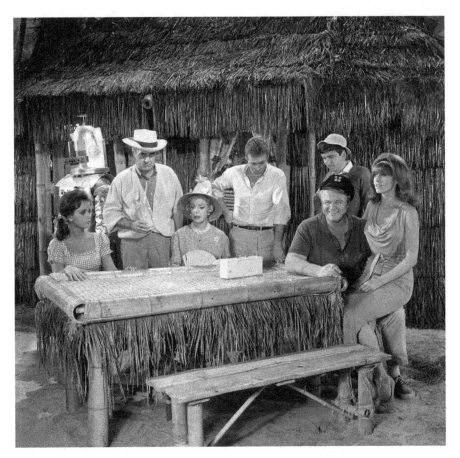

The castaways of *Gilligan's Island* built a bamboo and thatch paradise on their uncharted desert isle. *Warner Bros.*

rescuers. The viewer might reasonably conclude that Gilligan is secretly an evil genius keeping everyone else captive.

Some episodes were about the dangers of the South Seas, which were always strange and fantastic. In the episode "Waiting for Watubi," the Skipper comes across a Tiki idol called Kona he believes to be cursed. This modern "brave and sure" captain begins to sicken, and only by elaborately pretending to be an island deity does Gilligan cure the Skipper of his psychosomatic illness.

The show was knowingly absurd. The castaways were not trapped on the island because the forces of nature or an evil Gilligan kept them there—they were trapped because *we* kept them there and wanted to be

trapped with them. *The Beachcomber* had been about a man in a gray suit dropping out to live among palms and bamboo, but that took effort and guilt. How much better would be the fate of the castaways, forced by circumstance to live on an island paradise forever?

It wouldn't be better, of course. Most people would love two weeks on an island but not the rest of their lives away from family. Plus, what good is a life without antibiotics and modern emergency rooms, a life without schools for the inevitable children to come? But *Gilligan's Island* functions as an ever-recurring dream; the island is always *now* and always *away*. The castaways are lost forever, suspended in a waking Tiki torch–lit dream.

In 1967, *Gilligan's Island* was canceled to make room for a new timeslot for ABC's long-running *Gunsmoke*. But instantly the show became *more* ubiquitous rather than less, haunting syndication for decades to come (indeed, it runs today).

Sherwood Schwartz, the producer of *Gilligan's Island*, turned his attention immediately to another show that would cap off all of Tiki Culture: *The Brady Bunch*.

Running five seasons and 117 episodes in its original 1969–74 incarnation, *The Brady Bunch* told the story of the blended family of Mike and Carol Brady, who each brought three children into the new marriage. (Mike was a widower, while Carol's marital status pre-Mike was neither commented on nor revealed.) *The Brady Bunch*, while more grounded in reality than *Gilligan's Island*, was nevertheless the same sort of light confection, except with moral lessons each week, mostly about interpersonal dynamics like faith in family, patience and forgiveness.

In late September 1972, *The Brady Bunch* opened its fourth season with an unusual three-part story. Directed by Jack Arnold (who had brought us *The Creature from the Black Lagoon* in 1954), the episodes "Hawaii Bound," "Pass the Tabu" and "The Tiki Caves" brought all eight members of the Brady clan to Hawaii for an adventure involving presumably cursed Tiki idols. Here the curse is played straighter than on Schwartz's *Gilligan's Island*. The Brady boys learn about the cursed totem they find from one local boy who believes in the old superstitions and another who does not, allowing an argument about the value of traditional belief. The ultimate villain of the piece, meanwhile, is archaeologist Hubert Whitehead, played by Vincent Price, who wants fame for the discovery of the Tiki idol. In under ten years, the representation of the man of science on an exotic island has shifted from benevolent genius (*Gilligan's* Professor) to venal, greedy attempted murderer.

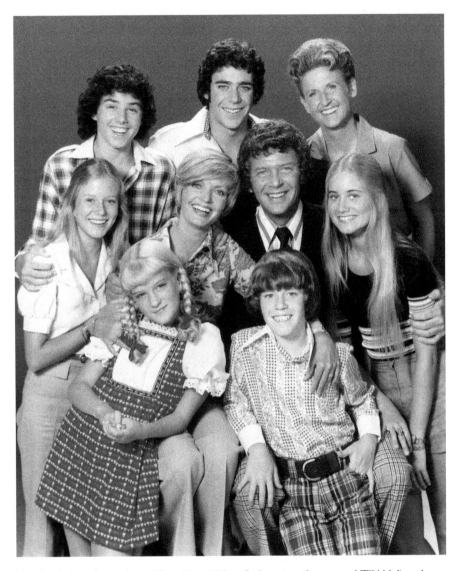

The Brady Bunch traveled to Hawaii in 1972 to find mystery (in a cursed Tiki idol) and danger at the hands of Vincent Price. *Warner Bros.*

This three-part episode of *The Brady Bunch* by no means brought about, but effectively marks, the end of Tiki Culture. Just six years after the final Elvis Hawaii movie (*Paradise, Hawaiian Style*) and just eleven years after the first (*Blue Hawaii*), the exotic getaway was now a familiar trope losing its potency.

The reason for this loss has to do with the immediacy of the symbolism of Tiki escapism. The height of Tiki Culture was a sublimation of the horrors of war in the South Pacific and Korea. It was *about* the need to escape from modern industrial life through a strange memory of a horror-filled time for the culture. By the early 1970s, society had moved on. Hawaii was now firmly a state, while stateside, the new generation was searching for a more permanent way of "dropping out" than merely creating a backyard getaway for a few hours after a workday in the city. The visual cues of Tiki would remain, but its cultural salience would continue to drift away.

7
Tiki Down

Woodstock Kills the Mai Tai

T he Tiki Culture movement as a popular expression of culture ended quickly in the late sixties and early seventies for a variety of reasons. Sven Kirsten links the end of Tiki to changing mores and politics:

After its sudden collapse in the midst of the anti-Vietnam War movement and the much more radical eroticization of the 1960s generation, the public quickly disinherited Tiki style as politically incorrect and in bad taste.

Indeed, this "abrupt wane in popularity" can be traced to three major narratives that called the salience of Tiki into question: the natural replacement of the Greatest Generation with the baby boomers, American preoccupation with the Vietnam War and a growing interest in "authentic" cultural experiences.

THE BABY BOOMERS

The World War II generation came home and got to work on work and family—the Man in the Gray Flannel Suit, Tom Rath, had three children of his own in that suburban house, one of many built quickly and quickly outgrown in the postwar years. By the late '60s, the baby boomers had come into their own as the tastemakers and culture consumers. To some extent,

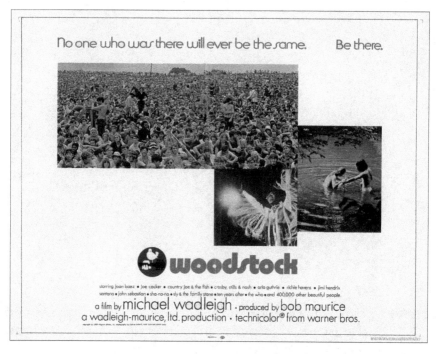

The poster for the 1970 documentary *Woodstock* about the history-making concert. *Warner Bros.*

the explanation of the death of Tiki could stop with the obvious observation that no set of teens wants to define themselves by their parents' cultural signposts. But boomer culture, particularly '60s and '70s hippie culture, clashed with Tiki in several specific ways.

In *Taboo: Time and Belief in Exotica*, musicologist Phil Ford noted that just as members of the Greatest Generation drew their culture from an imagined South Seas, the boomers drew the basic elements of hippie culture from cultural icons that represented their own ideals. Antiwar (particularly anti–U.S. Army) sentiments and free love were ideas that became associated with an imagined simpler, primitive man, and the most salient symbol of the type was the Native American as seen in the popular westerns on television every night. They adopted buckskin moccasins, fringe on their jackets, pared-down music, all markers borrowed from the western. This uniform can be seen all over images of Woodstock, the four-day concert in 1969 that was broadcast to the world first in the news and shortly thereafter in a hit documentary film and album.

The hippies embraced an idea of "free love" and overcoming the stuffy repression of their parents. "Love the One You're With" was completely at odds with Exotica music, which sublimated sex into a tension and attraction for the forbidden. If nothing is forbidden, then art about transgressing into the forbidden becomes irrelevant. Ford notes that "Whereas the counter-culture movement was about sexual liberation, Exotica had an anxiousness about sex— the forbidden 'other.'"

Tiki and Exotica didn't *stop* existing right away—as noted, Tiki still dominated through the end of *Gilligan's Island* in the late '60s and showed itself in the Tiki idol–fixated *Brady Bunch* three-parter in 1972. But Tiki became increasingly subordinate to more popular cultural expression, "a dead language" still spoken by a few. Shuhei Hosokawa explained that by the time Exotica performers were recording their variations of "Blowing in the Wind," Exotica was old hat, "nothing more than a standard arrangement." Exotica had been standardized and "universalized," familiar. Exotica was no longer exotic.

A lobby card for *Woodstock* plays up the hedonism and free love of the hippie movement. *Warner Bros.*

VIETNAM AND THE END OF THE EXOTIC

But nothing drove a wedge between the boomers and their parents as much as growing, fierce opposition among the young to the activities of the U.S. Armed Forces in the Vietnam War. With nine million students enrolled in college and exempt from the latest version of the draft, antiwar activity became a leading concern. Their reasons were many. Some opposed the war because of a distaste for the human costs of the war and a distrust of the "domino theory" that suggested that Vietnam was a crucial spot to fight the spread of communism. Some reasons were patently banal: one protestor said that demonstrations against the war were a social activity, "a great place to get laid, get high, and listen to some great rock."

None of that fit with Tiki Culture, which had been an expression of the dreams and nightmares of the Man in the Gray Flannel Suit, out to sublimate his experiences of adventure, romance and pain in foreign wars into a new idyllic setting at home. Tiki Culture was an expression that sprang from World War II and marked that generation and those who came shortly after, veterans of the Korean conflict. It was the boomers' parents' culture, and moreover, it was an echo of a theater of war that began to look less romantic every day.

A culture that sought to create a new dream based on Polynesia and the South Pacific, a realm of palm trees and nonwhite strangers, began to look troubling to those who opposed the Vietnam War. As awareness grew of the suffering wrought by and suffered by fighters in Vietnam, Tiki Culture began to seem "sinister." In short, Tiki lost favor because it looked too much like Vietnam.

MULTICULTURALISM AND THE YEARNING FOR AUTHENTICITY

The hippies who sought a "return to nature" by emulating presumed-innocent, non-Western people, wanted no part of Tiki and Exotica, which always placed the suburban, white American at its center. Whereas the post-modern sensibility of the hippies was "post-male, post-white, post-heroic," Tiki was grounded in the western ego, seeing "the other as object...whose manipulations and their consequences remain external to itself."

Francesco Adinolfi asserted, "There's a thin line between exoticism and racism, a line that is both very fragile and in a continual state of redefinition, depending on historical events and lived reality." Then and now, Tiki Culture was vulnerable to accusations of cultural appropriation and racism. Martin Denny, one of the creators of Exotica music, saw no such problem—to him (as with Les Baxter) he was creating "fiction," "just like a book." Denny was appalled by the idea that anyone would be offended by his music. Denny explained that Exotica captured "What a lot of people imagined the islands to be like" but that was actually "pure fantasy."

Inarguably, Exotica created an imaginary world of forbidden secrets by adopting westernized facets of an undifferentiated hodge-podge of cultures that ranged from Polynesia to Brazil. It was music intended to sound like no place in particular, but definitely not *here*, and *here* was always suburban white America.

The hippies, by contrast, sought inclusiveness and reform for marginalized groups, as the '60s saw the growth not just of the antiwar movement but also the women's liberation movement, the civil rights movement, the anti-nuclear power movement, the movement for the rights of Native Americans and more. The desire to fight for the marginalized led to a new embrace of authentic music. The 1972 album *The Concert for Bangladesh*, organized by ex-Beatle George Harrison, opened with a sixteen-minute sitar track by Indian musician Ravi Shankar. Harrison was still interested in mixing forms of music, using the sitar in a new version of *Norwegian Wood*, but the Les Baxter model—using "exotic" instruments to play what amounted to big band jazz—had been rendered hopelessly passé.

In his essay "The Culture of Tiki," Scott A. Lukas offered a challenge to Tiki:

> *Tiki's failure lies not in its soft misogyny, cultural appropriation and essentialism, or its willingness to align itself with the all-too-popular, kitschy, or campy forms of culture, but in its inability to act on the nascent counterinsurgency that is evident within its cultures. Concerns with Victorian sexuality and unrealistic expectations of masculinity could be addressed with new expressions of gender and sexuality perhaps paralleling metrosexuality and pansexuality trends outside of Tiki Culture, as well as with more critical reflections on gender, sexuality, race, and other intersectional and postcolonial issues. The desire to play with cultures in the plural, hybrid, and recombinant sense could be expressed with deeper reflections on the politics of appropriation which might result in the opening up of forms of cultural dialogue and Intercultural communication.*

A DVD cover for the 1978 *Fantasy Island*, featuring exotic locales and a mysterious host, played by Ricardo Montalban. *ABC.*

That's a tall order—Lukas is suggesting that the troubling appropriative aspects of Tiki could be solved by "deeper reflection" and dialogue, but how would that be accomplished in the modes through which Tiki tends to be expressed? The backyard barbecuer can't always stand next to the Tiki torch with a Mai Tai and comment to passersby about the inauthenticity of both. Rather the observer of Tiki either takes it for its far-ranging borrowing of culture or doesn't. Tiki can't pass Lukas's test because that's not how culture works.

Tiki master Sven Kirsten has noted that as the '70s turned into the '80s, many of the Tiki palaces and original artifacts of Tiki had been destroyed: "Completely razed or renovated beyond recognition, Polynesian palaces disappeared without ever having been acknowledged as a unique facet of American pop culture…unnoticed and without mourning, a whole tradition vanished."

Some semblance of Tiki did remain, "Jimmy Buffetized" in Kirsten's words, with shows like *Fantasy Island* and others employing generic tropical themes but detached from even the imaginary mixed culture of Exotica, removed from the sense of the forbidden world of the other. It would take years yet for Tiki Culture to make its resurgence.

8

Tiki Resurgence

The New World of Tiki (And What to Serve There)

Tiki Culture went to sleep for a number of years. When it finally returned at the tail end of the cocktail revolution of the 1990s, Tiki offered a different promise and played a different role from its original raison d'être. In the 1940s through the '60s, Tiki had been about a promise of adventure. To build a Tiki paradise in the backyard was to escape from the demands of an ever-expanding American economy into a world of painless adventure and limitless pleasure.

And as Sven Kirsten observed, in the 1970s and '80s, Tiki came to mean nothing at all. The motifs of Tiki—strange gods, different languages and a feeling of exploration—were all traded in for a much more generic motif of the South Seas island, what Kirsten calls the "Jimmy Buffett-ization" of culture. Margaritaville took in a certain amount of the last vestiges of Tiki; otherwise, it disappeared entirely. Old Tiki bars were torn down, and restaurants were converted into eateries that bore none of the faux Polynesian style that had defined Tiki.

And then, as if it had never been gone, Tiki returned. It returned in the form of artists, events, music and nightlife. But why?

The answer lay in what Tiki came to represent. Originally, Tiki represented a promise of adventure; now, Tiki represents the reclaiming of an American birthright. Because just as the drive-in movie theater is a uniquely American creation, the imaginary version of the South Seas presented in Tiki was a very distinct expression of postwar America. And whereas that expression originally represented Escape, now it can be remembered by the

contemporary American as the expression of America at a time very much to be admired and wished for. If in the 1950s to have a Tiki bar in one's house was to wish to escape the present for an idyllic South Seas alternate universe, today the same Tiki Bar represents a desire to escape the present for an idyllic 1950s. It represents an escape to a much more optimistic time, to a time when one could be free to complain about one's work in a world of unfathomable expansion. Modern Tiki is an expression of nostalgia for the time of confidence, happiness and style.

In this chapter, we will look at how Tiki has expressed itself in recent years and end with a look at the most key ingredient to a Tiki experience in one's home, and the easiest one to make a reality: the Tiki drink.

LIVE TIKI EVENTS

Tiki events represent a cultural shift to conventions in honor of pop culture. During the original Tiki period, conventions were uncommon except for industry trade fairs and science fiction conventions, which began in the late 1930s. Varied fan conventions began to expand as a concept in the 1960s. At that point, a Tiki convention wouldn't have made sense: today's fan conventions gather visitors to celebrate a shared interest that deviates somewhat from the default culture. From the late 1940s to the mid-1970s, Tiki was not a niche at all—for grown-ups, it *was* the default adult culture.

By the time of the first contemporary Tiki convention—Tiki Oasis, named by Sven Kirsten and founded in 2001—Tiki had become a recognizable counter-culture and niche style. There are several major Tiki events annually running in the United States, with the two largest on the West Coast, where Tiki culture began.

TIKI OASIS IN SAN DIEGO, CALIFORNIA

Tiki Oasis is the largest and longest-running "Polynesian Pop" festival in the world. Tiki Oasis was founded by Sven Kirsten and Otto and Baby Doe von Stroheim in 2001, with input from author and architectural preservationist Peter Moruzzi to celebrate the Polynesian Pop significance of the Caliente Tropics Motel in Palm Springs and save it from a Tiki-cleansing remodel.

Tiki Oasis features themes—2017 was all about international intrigue. *Tiki Oasis*.

After five years, Tiki Oasis successfully saved the Tropics, but the event outgrew the eighty-eight-room hotel, so Otto and Baby Doe moved Tiki Oasis to the historically Tiki-fertile locale of San Diego.

The five-day party, held at the former Hanalei Hotel (now the San Diego Crowne Plaza) and on Shelter Island at the historic Bali Hai restaurant, features educational symposiums during the day and live music at night. Symposiums feature internationally acclaimed bartenders, authors and experts in topics covering cocktail mixology, music, architecture, dance, history and more. DJs from around the world spin vintage vinyl all day during the indoor/outdoor shopping bazaar that takes over the entire grounds while a pool party rages on. Don't be surprised if you see a pop-up swimsuit show poolside or an impromptu fashion photo shoot at the car show—anything can happen at Tiki Oasis. Late at night, a world-class burlesque show abounds while guests are encouraged to attend semi-private room parties that often feature bands and professional bartenders showcasing their skills.

When it comes to live music, you get the best of the best in Exotica and surf music from new and original groups: vintage Exotica acts have included Robert Drasnin, Preston Epps and Jack "Mr. Bongo" Costanzo; classic surf acts have included the Lively Ones, Davie Allan & The Arrows, Donna Loren & The Shindiggers; other original 1960s groups that have played include the Standells, the Chocolate Watchband and the Sonics.

In addition to all this mayhem there are dozens of opportunities to partake in rum tasting and tropical drink imbibing—Tiki Oasis is a rum-

soaked adventure. Upon your departure you will feel as if you have traveled around the world and gained the experience and knowledge of a seafaring author/adventurer like Thor Heyerdahl or Jack London.

TIKI CALIENTE IN PALM SPRINGS, CALIFORNIA

Billing itself as "an annual event that creates the aura of island living," this spring event has been going on since 2008 and, like Tiki Oasis, runs for a long weekend in Palm Springs. Expect Tiki room crawls checking out drinks and gear, music parties and live performances. The 2017 show featured the "Meshugga Beach Party," a surf band translating traditional Jewish melodies into surf rock (a tradition begun by Dick Dale with his "Hava Nagila" surf track).

MAJOR TIKI BARS IN CALIFORNIA

Tiki bars have seen such a resurgence in the past decade that listing them all would be impossible. What defines a Tiki bar today is very much the same as what Kirsten described as the essentials of a Tiki bar in the classic era:

1. If possible, an *A-frame construction*—the hardest to accomplish for a Tiki bar and less common today as most of the old Tiki havens were torn down in the 70s
2. *Bridges to cross* inside the establishment, allowing the visitor to feel as though he is crossing a threshold into another world
3. *Jungle foliage* that captures light and makes one feel they've moved out of the everyday world and into the jungle
4. *Masks and weapons* on walls, a favorite cultural appropriation that harkens to a time of American explorers visiting other cultures and bringing back artifacts
5. *Tiki texture*: "floor-to-ceiling" use of "exotic woods, bamboo, rattan, tapa cloth, etc." plus dioramas and "white beachcomber lamps," though several Tiki bars have explored lighting even further into exotic lamps such as the lamps made from puffer fish found at the Royal Hawaiian and Don the Beachcomber

Don the Beachcomber is classic Tiki, including this A-frame entrance. *Jason Henderson.*

Tiki Bars give us the feeling of entering into a special world, with the only limit that of whether the theme fits Tiki Culture in general and whether it pushes too far into what the proprietor of the Royal Hawaiian called "Halloween"—or in the case of Anaheim's Trader Sam's, "Disneyland." (But that's okay for Sam's, because Sam's *is* Disneyland.)

ORIGINAL TIKI BARS STILL IN OPERATION

Bali Hai Restaurant

www.balihairestaurant.com
2230 Shelter Island Drive
San Diego, CA 92106

Open since 1954, Bali Hai Restaurant on the northern tip of Shelter Island is guarded by a great wooden head, "Mr. Bali Hai." The Tiki Oasis show is credited with bringing well-deserved attention back to this place.

Damon's Steak House

www.damonsglendale.com
317 North Brand Boulevard
Glendale, CA 91203

Established in 1937, Damon's is a longstanding steakhouse known for its BBQ and burgers that serves up Tiki cocktails. This place also acts as the locale of a nutty web series, a wonderfully snarky story of the (fictional) nutty people who work there.

Harbor Hut Morro Bay

www.harborhutmb.com
1205 Embarcadero
Morro Bay, CA 93442

Family owned and operated since 1951, the Harbor Hut boasts a waterfront location (and the attendant excellent view) and a reputation for excellent fine dining.

Minnie's in Modesto

minnie39.wixsite.com/minnies
107 McHenry Avenue
Modesto, CA 95354

Like the Tonga Room, Minnie's in Modesto is a Tiki bar that specializes in Asian cuisine. Open since 1954, it is guarded by a wooden Tiki and features a lovely patio and Tiki décor (including great black velvet paintings.) Their signature drink is the pink "jerk."

Royal Hawaiian in Laguna Beach

www.royalhawaiianlb.com
331 North Coast Highway
Laguna Beach, CA 92651

A refurbished classic bar and restaurant, the Royal Hawaiian is back to its 1940s glory with its own "Tiki Chic" style.

Palm trees and giant torches adorn the exterior of the Royal Hawaiian in Laguna Beach. *Jason Henderson.*

Tiki No

www.tikinola.com
4657 Lankershim Boulevard
North Hollywood, CA 91602

Where Clifton's is elegance, Tiki No embraces the kitsch. Features twice-weekly karaoke nights and "vintage TVs playing *Gilligan's Island*," Tiki No also boasts its own signature Tiki drink, a scotch (not rum)-based cocktail called the Raging Bull.

Tonga Hut

www.tongahut.com
12808 Victory Boulevard
North Hollywood, CA 91606

The Original Tonga Hut opened in 1958 calls itself "the oldest Tiki bar in Los Angeles." The excellent recent remodel includes lots of Tiki chic, including rattan and bamboo and groovy black velvet paintings.

Tonga Room

www.tongaroom.com
950 Mason Street
San Francisco, CA 94108

Located in the Fairmont Hotel in San Francisco, the Tonga Room (featuring Tiki drinks and Asian cuisine) has operated steadily since 1945.

Trader Vic's Flagship in Emeryville

http://tradervicsemeryville.com
9 Anchor Drive
Emeryville, CA 94608

One of the most famous Tiki bars in California. Opened in 1973, the Trader Vic's overlooking the San Francisco Bay and Emeryville Marina is a piece of original Tiki lore, a connection to Trader Vic Bergeron and Ernest Gantt, who set the table stakes for Tiki Culture.

Trad'r Sams

6150 Geary Boulevard
San Francisco, CA 94121

What *CriTiki* calls "the oldest, longest-operating Tiki bar in the world," Trad'r Sams (not to be confused with Disney's Trader Sams) was founded in 1937. Trad'r Sams in San Francisco is like a Tiki bar in hiding. The rattan and bamboo décor are still there, daring you to find the Tiki history here.

NEWER TIKI BARS

Clifton's LA featuring the Pacific Seas

www.cliftonsla.com/pacific-seas
648 South Broadway
Los Angeles, CA 90014

A beautiful joint on the classier side of Tiki, the Pacific Seas is the Tiki Room of Clifton's LA. Clifton's describes the bar in a way that sums up the Tiki experience expertly: *The Pacific Seas invites guests on an adventure—not to a time or a place, but to a mindset. Through the Art Deco Map Room guests find a celebration of the exotic, the mysterious—the unknown; a peek into the Golden Age of Travel through a uniquely Californian take on the romance of South Seas Culture.*

Don the Beachcomber in Huntington Beach

www.donthebeachcomber.com
16278 Pacific Coast Highway
Huntington Beach, CA 92649

Though it bears the name of an original, Don the Beachcomber in Huntington Beach is a new creation, a popular spot for Tiki drinks, live music and fantastic ambience of bamboo and Tiki art and sculpture. Donn Beach (born Ernest Gantt) conceived of the original Beachcomber as a place where "all senses are assaulted." The current location carries on that tradition.

Purple Orchid Tiki Lounge

221 Richmond Street
El Segundo, California

This spot in El Segundo is smaller than RH or Don's but has plenty of atmosphere to go with its Tiki drinks. You'll find fantastic art displays here—especially a wonderful shrunken head display and some unique paintings, including one of the 1960s-style Justice League fighting a Tiki god. Purple Orchid also bears a carved logo Tiki that matches the sign and graphics and a signature logo Tiki mug. As of this writing, the lounge doesn't have a website, but you can find information on the regularly updated Facebook page.

Test Pilot Bar

http://www.testpilotcocktails.com
211 Helena Avenue
Santa Barbara, CA 93101

Hidden away among the other gems of downtown Santa Barbara, this oasis of the north puts a decidedly craft-facing spin on traditional Tiki favorites—as well as serving up some surprises of their own. Nick Juhasz-Lukomski and his staff pour every ounce of their cocktailing skills and taste

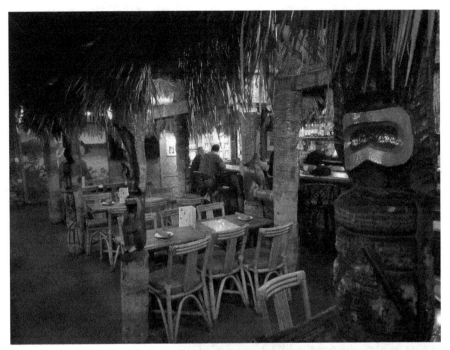

Above: The very Tiki interior of Don the Beachcomber in Huntington Beach. *Jason Henderson.*

Right: A garishly exciting shrunken head diorama in the Purple Orchid. *Jason Henderson.*

for liquid adventure into the stunning libations, guaranteed to slake the thirst of the most parched of paragliders (which is partly what drew me to the name) or rekindle the fires of many a wandering and jaded Tiki elite. A total surprise—but not one to forget.

Trader Sam's Enchanted Tiki Bar, Disneyland

disneyland.disney.go.com/dining/disneyland-hotel/trader-sams
Disneyland Hotel in Anaheim
1150 Magic Way, Anaheim, CA 92802

You don't have to have a ticket to Disneyland to enjoy this place, but Trader Sam's (which opened in 2011) is a fantastic Disney version of Tiki. Dioramas along the wall create three-dimensional island scenes in a dark jungle interior. Periodically, the place comes alive with lightning and thunder, as animatronics move and cast members get into the act, chanting and spraying "rain" water. Sam's wears its Disney family connections on its sleeves, with a drink called "Tiki Tiki Tiki Tiki Tiki Rum" and props from Disney properties like *Indiana Jones and the Temple of Doom* and *20,000 Leagues Under the Sea*.

Disneyland Hotel's Trader Sam's appears to be an A-frame Tiki palace bursting from a hidden jungle. *Jason Henderson.*

SPOTLIGHT ON TIKI DRINKS: THE TOP FIVE DRINKS YOU SHOULD KNOW FOR YOUR TIKI PARTY

The Tiki experience has always had a home element, and the right cocktails are crucial. We've gathered together classic recipes for the drinks you need to have in your back pocket if you want to make your Tiki party complete, from the classic Mai Tai to the Blue Hawaiian.

Mai Tai

Authentic Trader Vic's Mai Tais (the original from 1944), provided by Trader Vic's to *The Search for the Ultimate Mai Tai*

> *2 ounces 17-year-old J. Wray & Nephew Rum*
> *Juice of 1 lime*
> *½ ounce Holland DeKuyper Orange Curaçao*
> *¼ ounce Rock Candy Syrup*
> *½ ounce French Garnier Orgeat Syrup*

Pour rum and other ingredients over shaved ice. Shake vigorously. Add a sprig of fresh mint and spent lime shell.

Zombie

The Zombie was a 1930s invention of Don the Beachcomber's own Donn Beach. Based on the original Zombie, this recipe uses generic rums. The Zombie is *strong*, so although this is a recipe for one drink, you could easily share it over ice.

> *4 ounces (½ cup) water*
> *¾ ounce (1 ½ tablespoons) fresh lime juice*
> *1 ounce (2 tablespoons) fresh grapefruit juice*
> *½ ounce (1 tablespoon) sugar syrup*
> *1 ounce (2 tablespoons) dark rum*
> *1 ounce (2 tablespoons) golden rum*

1 ounce (2 tablespoons) white rum
1 ounce (2 tablespoons) 151-proof rum
1 ¼ ounces (2½ tablespoons) spiced golden rum
¾ ounce (1 ½ tablespoons) Cherry Heering
½ ounce (1 tablespoon) Falernum syrup
2 dashes (½ teaspoon) Pernod or other anisette-flavored pastis
3 dashes (¾ teaspoon) Grenadine

Shake with 4 ice cubes, then pour into 1, 2 or 3 highball glasses that have been filled with crushed ice.

Blue Hawaiian

A sea-colored variation of the Piña Colada, the Blue Hawaiian is a favorite on both sides of the Pacific.

1 ounce light rum
1 ounce blue curaçao
2 ounces pineapple juice
1 ounce cream of coconut
1 slice pineapple
1 cherry

Blend light rum, blue curaçao, pineapple juice and cream of coconut with one cup ice in an electric blender at high speed. Pour contents into a highball glass. Decorate with the slice of pineapple and a cherry.

Planter's Punch

Traditional Tiki drink associated with the Planters Hotel in Charleston, South Carolina.

1 ½ ounces dark rum
1.2 ounces fresh orange juice
1.2 ounces fresh pineapple juice
¾ ounce fresh lemon juice
⅓ ounce Grenadine syrup

⅓ ounce sugar syrup
3 or 4 dashes Angostura bitters

Pour all ingredients, except the bitters, into shaker filled with ice. Shake well. Pour into large glass, filled with ice. Add Angostura bitters on top. Garnish with cocktail cherry and pineapple.

Singapore Sling

Though usually made with gin, the Singapore Sling has a long association with Tiki.

1 ounce gin
½ ounce cherry liqueur (cherry brandy)
¼ ounce Cointreau
¼ ounce DOM Bénédictine
⅓ ounce Grenadine
4 ounces pineapple juice
½ ounce fresh lime juice
1 dash Angostura bitters

Pour all ingredients into cocktail shaker filled with ice cubes. Shake well. Strain into highball glass. Garnish with pineapple and cocktail cherry.

INTERVIEW WITH HASTY HONARKAR OF THE ROYAL HAWAIIAN, LAGUNA BEACH

Laguna Beach, California, is the perfect getaway for the Tiki enthusiast looking for a secret getaway.

Tucked away—almost hidden—on the Orange County coast about an hour from LAX, Laguna Beach is home to the annual Pageant of the Masters, which showcases fine art and incredible live recreations of famous paintings. Classic hotels here hearken back to the heyday of Tiki—the Laguna Riviera, built in 1948, features sea view rooms and a homey, classic California feel, almost as though you could wander out by the grill on the large terrace and run into Victor Mature. The elegant

The historic Laguna Riviera in Laguna Beach offers beach views in a 1950s-style hotel. *Laguna Riviera.*

Hotel Laguna, meanwhile, was built in the 1880s and offers not only fine dining but also an excellent exhibit of historical photographs showing the history of this seaside community.

The jewel of Laguna Beach and the most authentic historic Tiki bar in Southern California is the Royal Hawaiian, which opened in 1947 at the height of the Tiki boom. The restoration of this historic bar and restaurant is a success story that begs a trip.

Hasty Honarkar is the creative director and co-owner of the Royal Hawaiian. For years, the bar and restaurant changed hands and eventually became "not quite a Tiki bar at all" before Honarkar's developer family bought the place, and Honarkar fell in love with the idea of "Tiki chic." She has set out to become an ambassador of Tiki.

After changing hands many times, the Royal closed in 2012, and it would lie dormant from its Ohana for four long years.

The Royal Hawaiian official history tells it:

> *The Royal Hawaiian lived in shambles until Mo Honarkar purchased it in 2015 and began renovating it in 2016 alongside his daughter Hasty Honarkar and son-in-law Eric Bostwick. Mo, a local in the city*

Above: The classic sun-drenched beachside exterior of the Laguna Riviera. *Laguna Riviera.*

Left: The Hotel Laguna is the home of beach life history, featuring fine dining and an exhibit of vintage photos from the hotel's long life. *Hotel Laguna.*

of Laguna, wishes to bring back a piece of Laguna Beach history. His aim is to give the Royal Family a place to feel nostalgic while giving the next generation their turn at making Royal memories. He, along with his daughters—Hasty Honarkar and Nikisa Honarkar Bostwick, hope to bring the Royal Hawaiian back to life. Today, his team strives to bring back the spirit of the Islands to the Laguna Beach community.

Following the Royal's history, the Honarkars have incorporated as many relics of the past as possible. The banana leaf, so prominent in island culture as well as revered through the Beverly Hills Hotel in the 1940's, can be seen throughout the restaurant. Pineapples, a symbol of welcome, hospitality, and friendship, can be seen around every corner. Many are gold as it is the ROYAL Hawaiian, and all who enter are a part of our Royal Ohana.

There are Tikis throughout the restaurant to commemorate the Tiki era from which the restaurant was born, as well as illustrating how Tiki is evolving in the future. When walking into the Royal, you will be surrounded by the famous Bamboo Ben's work! Other artists' work you may find are Tiki Diablo, the WORLD FAMOUS Tiki Farm, Tiki Bosko, MunkTiki, and more! Blowfish remind us of those tropical fish in Hawaii as well as those that lived in the Royal during the Cabang era. You can find our puffer-fish lights from the WORLD RENOWNED Oceanic Arts! Beautiful art from local artists, upcoming Hawaiian artists, and a little beauty from around the world in our Royal Hawaiian staff :)

When the authors met with Hasty Honarkar at the Royal, the renovated restaurant was back to its former glory and then some. While we drank signature Lapu Lapus and tried out menu items like the Hamachi Sashimi and Royal Hawaiian Burgers, Hasty talked about her philosophy of "Tiki chic."

"The fans know Tiki," Hasty says, "and they'll tell you the way to go." Hasty was determined to create a space that was tasteful and responded to the Tiki community's expectations. She manages the restaurant's online presence through Twitter, Facebook and Instagram and was determined to show that she respected the traditions. "For instance," she says, "it's taboo in a Tiki bar to have a TV—you don't want to become a sports bar. Plus you need the darkness to feature the atmosphere and the art." But you can have a TV showing the right movies, for instance.

Art is everywhere, such as the aforementioned Oceanic Arts puffer fish lamps, but Hasty is keen not to overstuff the restaurant. She says the creation of a Tiki space requires the careful navigation of the space between too much performance and set dressing, such as at the much more flash Trader Sam's ("but that's Disneyland," she noted) and not enough. "It's all about layers," Hasty said. "Layers upon layers of Tiki experience." The bar is divided into sections for intimate dining versus the bar, where live music plays regularly.

She wants the Royal Hawaiian to be a family restaurant and sees people come in with grandchildren who tell her they remember the Royal from the past. Consequently, she feels a real sense of duty to create the right experience. "A lot of Tiki bars are not kid friendly, but it's important to us. People come with second and third graders. So the Tiki needs to be familiar but dramatized, and capture *O'Hana*, the family feeling. Tiki done the right way should be darkness with a little cocktail umbrella, both dangerous and familiar."

Right: A pineapple lamp, the symbol of the Royal Hawaiian. *Jason Henderson.*

Below: The Royal Hawaiian's classy, bamboo-lined interior. *Jason Henderson.*

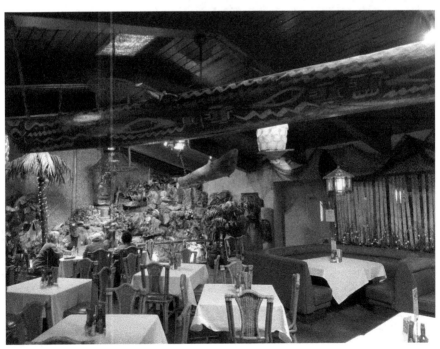

Throughout the restaurant, the symbol of the pineapple recurs, which Hasty says represents warmth and hospitality. Besides the excellent food and signature drinks, the RH specializes in collector Tiki mugs designed by local artists and commemorating different events and anniversaries, ranging in price from thirty to eighty dollars.

"This is a real place," she says. "When I came in after the renovations and I saw the bamboo on the walls, I felt transported. That's what I want: a real place Tiki, a Tiki place, rather than a set."

The Royal Hawaiian, once again a jewel of the West Coast, has become the home of Tiki chic.

9
Some Final Thoughts

W hen we first set out to explore the world of Tiki Culture, we had only the faintest idea of what we were getting into. Every new discovery led to even more discoveries beneath that. We knew that Tiki was a culture of palm trees and vaguely Hawaiian-sounding music, of Tiki torches and Mai Tais, but it was only when we started researching it that we began to find the heart beneath it all.

Tiki Culture was more than a style that dominated the postwar years. It was an expression of the yearnings and anxieties of Americans trying to find their place in an expanding economy that often left men and women bereft of meaning. Americans constructed Tiki palaces and festooned their backyards with palms and torches in an effort to create a visceral, aural, tactile escape to a world that never existed except in their dreams: an island paradise where the pressures of the Gray Flannel Suit and the house-beautiful tyrannies of women's magazines could be set aside.

The unreality of Tiki is as impossible to reckon with as it is important. The elements of Tiki were borrowed from other real cultures, and over the years, writers have debated how much to be appalled at the cultural appropriation to be found there. Tiki music might be a little bit Hawaiian and a little bit Brazilian; Tiki architecture was a little bit Micronesia and a little bit Maori. Those sources are real places, and the seamen who found respite in the islands between shellings were guests of land belonging to real people—people whose island paradises had actual histories that Tiki Culture generally ignored. Tiki Culture borrowed liberally from all of these

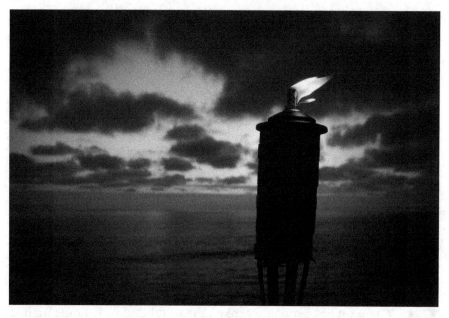

The mainstay of any backyard paradise: Tiki torch. *Kevin Finneran.*

and mixed them together, using the "other" as a means of exploring the dreams of Americans. This "otherness" leads to a problem of exclusion—at first glance, this is a culture distinctly built around a largely white, largely suburban American community.

But fantasy knows no one community. Tiki is always inauthentic except in its capture of dreams, and as recent followers of Tiki have learned, any person can be lost in the hypnotic mix of cocktails, rhythmic music and shadowy, enticing atmosphere. Tiki has gone to sleep and reemerged as an escape from new anxieties and a modern world as alienating as postwar suburbia ever was.

Tiki is for everyone.

Sources

Adams, Michael C.C. *The Best War Ever: America and World War II*. Baltimore, MD: Johns Hopkins University Press, 1993.

Adinolfi, Francesco. *Mondo Exotica: Sounds, Visions, Obsessions of the Cocktail Generation*. Durham, NC: Duke University Press Books, 2008.

Andrews, Bart, and Brad Dunning. *The Worst TV Shows—Ever: Those TV Turkeys We Will Never Forget (No Matter How Hard We Try)*. New York: Dutton, 1980.

Anolik, Lili. "One Summer, Forever." *Vanity Fair*, March 2014.

Biddiscombe, Perry. "Dangerous Liaisons: The Anti-Fraternization Movement in the U.S. Occupation Zones of Germany and Austria, 1945–1948." *Journal of Social History*, 34 no. 3 (2001): 611–47.

Blair, John. *Southern California Surf Music, 1960–1966*. Charleston, SC: Arcadia Publishing, 2015.

Cave, Rick. *Stranded: The Definitive Guide to Gilligan's Island*. Createspace, 2015.

Crowley, Kent. *Surf Beat: Rock 'n' Roll's Forgotten Revolution*. New York: Backbeat, 2011.

Eikenberry, Karl W., and David M. Kennedy. "Americans and Their Military, Drifting Apart." *New York Times*, May 27, 2013. http://www.nytimes.com/2013/05/27/opinion/americans-and-their-military-drifting-apart.html.

Fitzgerald, Jon, and Philip Hayward. "Tropical Cool: The Arthur Lyman Sound," in *Widening the Horizon: Exoticism in Post-War Popular Music*, edited by Philip Hayward, 94–113. Sydney: John Libbey, 1999.

Flaherty, Joseph. "The Bizarre Rise and Fall of the Tiki Bar." *Wired,* July 16, 2014.

Ford, Philip. "Jazz Exotica and the Naked City." *Journal of Musicological Research* 27 (2008): 113–33.

———. "Taboo: Time and Belief in Exotica." *Representations* 103 (Summer 2008).

Friedler, Leslie. "The New Mutants." *Partisan Review* (1965): 32, 505–25.

Fussell, Paul. "My War: How I Got Irony in the Infantry." https://harpers. org/sponsor/thewar/wwiiharpers/my-war-how-i-got-irony-in-the-infantry.

Halterman, Del. *Walk—Don't Run: The Story of the Ventures.* Lulu, 2009.

"Hawaii Crime Rates 1960–2015." http://www.disastercenter.com/crime/hicrime.htm.

Hayward, Philip. "The Cocktail Shift," in *Widening the Horizon: Exoticism in Post-War Popular Music*, edited by Philip Hayward, 1–18. Sydney, AU: John Libbey, 1999.

Hosokawa, Shuhei. "Martin Denny and the Development of Musical Exotica," in *Widening the Horizon: Exoticism in Post-War Popular Music*, edited by Philip Hayward, 72–93. Sydney, AU: John Libbey, 1999.

Hyp Records: Vinyl Safari. "Arthur Lyman." hipwax.com/music/exot_al.html.

———. "Exotica." www.hypwax.com/music/exotica.html.

———. "Les Baxter." hipwax.com/music/exot_lb.html.

———. "Martin Denny." hipwax.com/music/exot_md.html.

———. "Yma Sumac." hipwax.com/music/exot_ys.html.

Kirsten, Sven. *Tiki Pop: America Imagines Its Own Polynesian Paradise.* Los Angeles, CA: Taschen, 2015.

———. *Tiki Style.* Los Angeles, CA: Taschen, 2004.

Kohner, Frederick. *Gidget.* New York: Berkeley Books, 2001.

Leydon, Rebecca. "Utopias of the Tropics: The Exotic Music of Les Baxter and Yma Sumac," in *Widening the Horizon: Exoticism in Post-War Popular Music*, edited by Philip Hayward, 45–71. Sydney, AU: John Libbey, 1999.

Locke, Ralph. "A Broader View of Musical Exoticism." *Journal of Musicology* 24, no. 4 (2007): 477–521.

Los Angeles Times. "Anthony Eisley, 78; Television Detective and B-Movie Actor." February 3, 2003.

Lukas, Scott A. "The Cultures of Tiki." In *A Reader in Themed and Immersive Spaces.* Pittsburgh, PA: Carnegie Mellon, 2016.

MacPherson, Myra. *Long Time Passing, New Edition: Vietnam and the Haunted Generation*. Garden City, NJ: Doubleday, 1984.

McIntosh, Martin, Sven Kirsten and Boyd Rice. *Taboo: The Art of Tiki*. Melbourne, AU: Outre Gallery Press, 1999.

New York Times. "Yma Sumac, Vocalist of the Exotic, Dies at 86." November 4, 2008.

Priore, Domenic. *Pacific Ocean Park: The Rise and Fall of Los Angeles' Space Age Nautical Pleasure Pier*. Port Townsend, WA: Process, 2014.

Ruhlmann, William. "Dominic Frontiere: Pagan Festival: An Exotic Love Ritual for Orchestra." AllMusic. www.allmusic.com/album/pagan-festival-an-exotic-love-ritual-for-orchestra-mw0000984715.

Sisario, Ben. "Martin Denny, Maestro of Tiki Sound, Dies at 93." *New York Times*, March 5, 2005.

Smith, Kevin Burton. "Hawaiian Eye." Thrilling Detective. http://www.thrillingdetective.com/hawaii.html.

Space Age Pop Music. "Dominic Frontiere." http://www.spaceagepop.com/frontier.htm.

Spiers, Katherine. "Tiki's Hollywood Origins and the Woman Behind It All." Serious Eats, 2015. https://www.seriouseats.com/2015/03/tiki-history-hollywood-cocktails-food-sunny-sund.html.

Statistic Brain. "World War II Statistics." http://www.statisticbrain.com/world-war-ii-statistics.

Stevenson, Adlai E. "A Purpose for Modern Woman." *Women's Home Companion* (September 1955): 30–31.

Stewart, Dick. "Up Close with Michael Z. Gordon of the Marketts." *Lance Monthly*, May 15, 2005.

Strongman, Jay. "Tiki Revival: Paradise Regained," in *Tiki Mugs*, 33–59. London: Korero Books, 2008.

TV Terror. "EP016: The Bradys Fall Under the Curse of an Ancient Hawaiian Idol, TABU." April 18, 2017. http://tvterrorshow.com/ep016-the-bradys-fall-under-the-curse-of-an-ancient-hawaiian-idol-the-tabu.

Vallance, Jeffrey. "Hangin' With the King of Tiki," in *Tiki Art Two: The Second Coming of the New Art God*, edited by Otto von Stroheim, 6–10. San Francisco, CA: 9mm Books, 2005.

von Stroheim, Otto. "The Second Coming of the New Art God," in *Tiki Art Two: The Second Coming of the New Art God*, edited by Otto von Stroheim, 12–13. San Francisco, CA: 9mm Books, 2005.

Whitburn, Joel. *The Billboard Hot 100 Charts: The Sixties*. Milwaukee, WI: Hal Leonard Books, 1990.

Wilson, Sloan. *The Man in the Gray Flannel Suit*. New York: Da Capo Press, 2002.

World War II Foundation. "WWII Facts & Figures." http://www.wwiifoundation.org/students/wwii-facts-figures.

Index

A

Arkoff, Samuel 71
Astronauts, the 53, 61
A Summer Place 62, 68, 69, 81
Atkins, Chet 56
Avalon, Frankie 57, 69

B

Bachelor in Paradise 75, 77
Backus, Jim 82
Bali Ha'i 20
Bali Hai Restaurant 98
Batman 10
Baxter, Les 40, 43, 46, 47, 48, 50, 51, 91
Beach Blanket Bingo 71
Beach Boys, the 55
Beachcomber, The 79, 84
Beach, Donn 27

Beach Party 69
Beatles, the 54, 91
Bel-Airs, the 51
Big Kahuna 62
Bikini Beach 71
Billboard Hot 100 57
Bing Crosby 41
"Blowin' in the Wind" 42
Blue Hawaii 72, 73, 74, 85
Blue Hawaiian 105, 106
Brady Bunch, The 84, 85
Brown, Bruce 53, 57
Buffett, Jimmy 93
Busch Gardens 10

C

Carson, Lance 51
Chantays, the 54, 60
Clifton's 100, 101
Conrad, Robert 81

Creature from the Black Lagoon, The 84
Cummings, Robert 69

D

Dale, Dick 40, 51, 53, 54, 55, 56, 57, 58, 60, 61, 71, 96
Damon's Steak House 98
Darren, James 64, 66
Dee, Sandra 64, 65, 66, 69, 71
Denny, Martin 30, 40, 41, 47, 48, 49, 50, 51, 55, 91
Disneyland 9, 30, 31, 97, 104, 110
Donahue, Troy 68, 69, 73, 81
Donovan's Reef 75, 76, 77
Don the Beachcomber 27, 30, 40, 47, 54, 96, 102, 105
Dr. Goldfoot and the Bikini Machine 71

E

Eddy, Duane 52
Ed Sullivan Show, The 54
Egan, Richard 68
87th Precinct 78
Eisley, Anthony 73, 81, 82
Enchanted Tiki Room 31
Endless Summer, The 53, 57
Exotica 40, 41, 47, 48, 54, 88, 89, 90, 91, 92
Experiment in Terror 59

F

Fantasy Island 92
Fender Musical Instruments Company 53
Fender Reverb Unit 53
Fireball 500 71
Ford, Philip 41, 42, 43, 88
Frontiere, Dominic 44
Funicello, Annette 57, 69
Fussell, Paul 32, 37

G

Georis, Walter 52
Get Yourself a College Girl 70
Ghost in the Invisible Bikini, The 71
Gibson 57
Gidget 62
Gidget Gets Married 68
Gidget Goes Hawaiian 66
Gidget Goes to Rome 66
Gidget Grows Up 68
Gidget's Summer Reunion 68
Gilligan's Island 82, 84, 89, 100
Girls! Girls! Girls! 72
gold rush 26
Googie 9, 10
Great Gildersleeve, The 70
Griffith Park 10
Grog Log, The 12

H

Hale, Alan Jr. 82
Harbor Hut 98

Harrison, George 91
Hawaiian Eye 47, 73, 79, 80, 81, 82
Hawaiian Village Hotel 49
Hawaii Five-O theme 57
Hayward, Philip 42
Heston, Charlton 46
Heyerdahl, Thor 17, 18, 20, 22
Hilton Hawaiian Village 73
hippie culture 42, 88
Hirohito 19
Honarkar, Hasty 107, 108, 109, 110
Hosokawa, Shuhei 41, 42, 89
How to Stuff a Wild Bikini 71

J

Japanese Village & Deer Park 10

K

Kaiser Dome 49
Kingston Trio 55
Kirsten, Sven 12, 34, 79, 80, 87, 92, 93, 94
Knott's Berry Farm 9
Kohner, Frederick 62
Kohner, Kathy 62
Kon-Tiki 17
Kon Tiki Ports 11

L

Leydon, Rebecca 45
Lukas, Scott A. 51, 91, 92
Lyman, Arthur 49

M

Mai Tai 28, 87, 92, 105
Mancini, Henry 59
Man in the Gray Flannel Suit, The 32, 33, 35, 37, 69, 78, 79, 84, 87, 90, 113
novel 32
Marketts, the 59, 60
Matson Cruise Lines 11
McKay, Gardner 79
Michener, James 19, 20, 22, 23, 25, 26, 30, 31, 37, 75
Mickey Mouse Club, The 69
Minnie's 99
"Misirlou" 49, 53, 55
Muscle Beach Party 71

N

New Gidget, The 68
"Night Owl" 56
Norwegian Wood 91

O

O'Hana 110
Out of Limits! 59

P

Pacific Ocean Park 10
Pacific Theatre 19
Pagan Festival 44
Pajama Party 71
Paradise, Hawaiian Style 72, 74, 75, 85

Peck, Gregory 32, 78
"Peppermint Man" 56
Pipeline 60
Playhouse 90 78
Ports O' Call 10
Presley, Elvis 72
Purple Orchid 102

Q

"Quiet Village" 43, 47, 48, 50

R

Rebel Without a Cause 10
Richman, Caryn 68
Rickles, Don 57
Ritual of the Savage (Le Sacre du Sauvage) 43
Robertson, Cliff 64, 65
Rousseau 26
Royal Hawaiian 51, 66, 96, 97, 99, 107, 108, 110, 112
Ruhlmann, William 45

S

Sandals, the 57
Santo & Johnny 57, 61
Schwartz, Sherwood 82
Secret of the Incas 46
77 Sunset Strip 78, 80
Sgt. Deadhead 71
Shadows, the 61
Shafer, Natalie 82
Shankar, Ravi 91

Ski Party 71
"Sleep Walk" 56
"Sloop John B" 55
South Pacific 20, 22, 25, 31, 33, 37, 39, 41, 62, 75, 77, 79, 86, 90
Stevens, Connie 80, 81
Stevenson, Adlai 34, 39
Sumac, Yma 45, 46, 47
Surfaris, the 51, 54, 58, 61
Surfers' Choice 55

T

Taboo 49
Tales of the South Pacific 19, 37, 75
Tammy and the Doctor 71
Three Coins in the Fountain 66
Thunder Alley 71
Tiki
 definition 23
Tiki No 100
Tiki Oasis 94, 96
Tonga Hut 100
Tonga Room 99, 100
Trader Sam's 97, 101, 104, 110
Trader Vic's 11, 27, 28, 101, 105
Twilight Zone, The 59

V

Vallance, Jeffrey 11
Ventures, the 56, 57, 59, 60, 61
Vietnam 40, 42, 54, 58, 87, 90
Voice of the Xtabay 45, 49
von Stroheim, Otto 9, 94

W

Walk Don't Run 56
Waterman, Willard 70
Welk, Lawrence 60
Wilson, Sloan 69
Winchell, Walter 46
Woodstock 42, 87, 88

Z

Zombie (drink) 105

About the Authors

Jᴀꜱᴏɴ Hᴇɴᴅᴇʀꜱᴏɴ has written games for EA, Microsoft, Activision and more. He is the author of the popular middle-grade series *Alex Van Helsing* from HarperCollins and the 2019 series *Young Captain Nemo* from Macmillan. He wrote the magical romantic comedy *Sylvia Faust* for Image Comics; the assassin thriller *Daughters of the Shadow* for Marvel; co-wrote *Clockwerx*, a steampunk adventure about a woman who runs a Victorian mech team, for Humanoids; and co-wrote the teen adventure *Psy-Comm* for Tokyopop. This is his first nonfiction book.

Standing squarely at the transmedia crossroads of entertainment and technology, Aᴅᴀᴍ Fᴏꜱʜᴋᴏ has always been fascinated by great stories and even greater ways to tell them. With over thirty interactive, television and film titles to his credit, Adam has written for some of the most successful and enduring franchises in entertainment history—including Call of Duty, Skylanders, Destiny, James Bond and Transformers. Adam's interest in Tiki was sparked by stories from its early Hollywood origins, fueled by the promise of exotic travel and adventure and, as someone who creates worlds for a living, passionately continues to this day.

CPSIA information can be obtained
at www.ICGtesting.com
Printed in the USA
BVHW051614141221
624010BV00003B/360